SECRET
LOUGHBOROUGH

Lynne Dyer

AMBERLEY

Acknowledgements

Photographs are taken by the author. The following were reproduced by kind permission: *Synchronised Swimmers*, thanks to Lucy Buzzacott, Mike Jones, Abi Ross and Charnwood Borough Council (CBC); *Lady Jane Grey*, to Wei Ong and CBC; Hospital Way mural, Barry Bulsara and David Eden; *Signaler*, John Atkin and Rushes Shopping Centre; *Sockman*, Shona Kinloch; Swan Maze and Charnwood Heritage plaque, CBC; *Pinau Statue* and Leicestershire green plaque, Leicestershire County Council (LCC); and the Garden of Remembrance and cedar tree, Loughborough University.

Thanks also to LCC for kindly providing a copy of the Skevington portrait.

I would like to thank my family and friends for their help and support while I've been researching and writing this book.

First published 2019

Amberley Publishing
The Hill, Stroud
Gloucestershire, GL5 4EP

www.amberley-books.com

Copyright © Lynne Dyer, 2019

The right of Lynne Dyer to be identified as the Author of this work has been asserted in accordance with the Copyrights, Designs and Patents Act 1988.

ISBN 978 1 4456 8824 4 (print)
ISBN 978 1 4456 8825 1 (ebook)

British Library Cataloguing in Publication Data.
A catalogue record for this book is available from the British Library.

Origination by Amberley Publishing.
Printed in Great Britain.

Contents

Introduction

'So, you live in Loughborough. Where's that exactly?' Clearly, the location of Loughborough itself is a big secret, and the town has so many secrets that this book can reveal only a few. The stories contained herein may or may not be well known. Perhaps they were once known, but are now no longer remembered. Or perhaps meanings are hidden, overlooked or taken for granted. Many of today's secrets were never meant to be secrets, but over time their meaning has been lost.

Do we ever stop and wonder about the unusual Town Hall clock? Or why there is a fountain and a 'sock man' statue in Market Place? Or why we have a White Hart pub? Or why there is a street called Peter Laslett Close? Or why so many town centre buildings are tiled? Or which street won an award for being the best decorated during the coronation of Elizabeth II in 1953? The answers to these questions, and many more, can be found within the pages of this book, which aims to tell the less familiar story of Loughborough.

Loughborough has been around for hundreds of years, appearing in the Domesday Book of 1086 as 'Lucteburne'. Henry III granted Loughborough a market charter in 1221 and a fair charter in 1228 and today markets and fairs are held regularly. After Leicester, Loughborough is the biggest of the county's towns, and sits neatly between Leicester, Nottingham and Derby. Its transport links are fantastic: close to the M1 and A/M42, having a speedy train link to London, Birmingham and the north of England, and being close to East Midlands Airport. The Grand Union Canal passes through the town, which, although once a busy, working canal, is used mostly for pleasure boating. The Charnwood Forest Canal was also a working canal, but has long been deserted. The Great Central Railway, which attracts huge numbers of visitors each year, was part of the London extension destined for Marylebone station. This was one of three railways in the town, the others being the existing Midland Main Line and the now defunct Charnwood Forest Railway.

The significance of the names of many public houses may have long been forgotten, but at one time such names were widely recognised, often reflecting national events and characters, and local usage provides an insight into the history of Loughborough. The same is true of the local street names, with some honouring national figures, others local ones, and much of the history of the town is reflected in the street names we see today.

Like many towns that thrived in the Victorian period, Loughborough created a park near its centre, where there is a strong connection with nature, but this isn't the only place where flora and fauna have an important part to play in the history of the town.

Secrets can be hidden anywhere, but we are usually so focused on looking ahead that we can miss some really interesting clues. So, it's important to look up, down and around when walking anywhere in order to spot things that are not immediately obvious.

The history of firms that were either locally born or based can be seen all around us in buildings that have been abandoned, reused or their sites redeveloped, in reminders that pop up annually or in companies that still operate out of the town. A handful of these are mentioned in this book, followed by a short chapter on an eclectic mix of characters and notable people who have some connection with Loughborough. Secret and not-so-secret societies in Loughborough have also been incredibly important to the development of the town over the years, and a selection of these have been included.

Begun as Loughborough College in 1919 and granted its charter in 1966, the university is renowned for the sporting prowess of its students and alumni, and has a good reputation. Although the university is well known, today it is still yielding some of Loughborough's secret past within its grounds.

Finally, what would a book about secrets be without mention of ghosts, fairies and ... brick walls?!

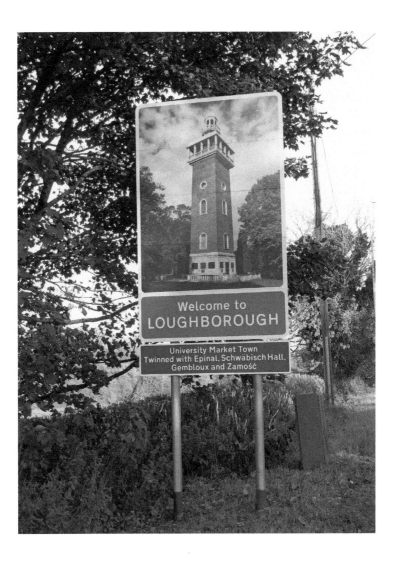

Welcome to Loughborough.

1. What's in a Name?

Pubs

When in 1770 Thomas Pochin wrote his account *An Historical Description of Loughborough*, there were forty-three public houses in the town – a ratio of one for each 100 inhabitants. These establishments would have been a mix of public houses, beerhouses, hotels and inns – some tied, and others free houses. The history of the town and its people can be traced through the variety of names bestowed on these hostelries.

Differences between the function of the various establishments were sometimes obvious from the name: The Bulls Head Hotel Commercial and Posting House was a hotel and drop-off and pick-up point for the Manchester–London mail coach, while the Old Pack Horse Inn (building dated 1781 and now named the Organ Grinder) was a place where weary travellers could rest and exhausted horses be fed and watered or changed for a new team.

Ale or beerhouses, where beer was brewed at home for sale to passers-by, would indicate their purpose by hanging an ale pole outside the property. A law passed as early

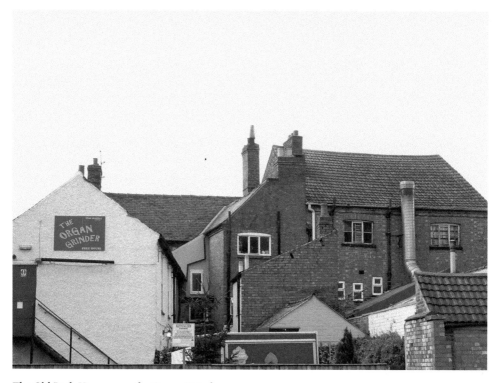

The Old Pack Horse, now the Organ Grinder.

as 1393 made the hanging of a sign mandatory, and it was these ale poles that led to the hanging of more pictorial signs, like those seen today. Some of these signs are based on very traditional signs and symbols used as long ago as Roman times to indicate that a building was a hostelry. These three-dimensional signs were used because many people were illiterate, so a physical indication, like a significant sign, made the purpose of the hostelry more apparent to all. Some former Loughborough pub names – like the Grapes or White Grapes (Swan Street) or the Vines (Nottingham Road) – were based on these traditional Roman signs.

Some Loughborough pub names are based on the brewing industry itself; for example, the Barley Mow (Market Street), a mock Tudor pub that closed in 2004. Today part of the building has been converted into a micropub. Other pub names are related to widespread religious emblems, like the Anchor on the High Street (now defunct) and the Cross Keys, also on the High Street, which today is the Phantom.

The Firkin Brewery chain took over the Cross Keys in 1994. It was their usual practice to name a pub 'The X and Y', where both words began with either an 'F' or a 'Ph', hence Loughborough's Cross Keys became the Phantom and Firkin. Names chosen by the brewery were always associated with the local area or to some connection with the physical building – it is widely believed that the Cross Keys was a haunted pub, hence the new name. The Firkin Brewery chain was taken over by a variety of other brewers, and Loughborough's pub was transferred to the It's a Scream chain, later known simply as Scream. The pub name was amended slightly to The Phantom, thus preserving its association with the hauntings. Other public houses in Loughborough that are reputed to be haunted include The Windmill on Sparrow Hill, The Royal Oak on Leicester Road, the former Bull's Head (now a hairdresser) on High Street, and the former Ram Inn (now a dry cleaner) on The Rushes.

DID YOU KNOW?

At one time the Green Man, an Offilers Ales pub, was a pub just like any other, nestled between Tylers seedsmiths and Gerald Grudgings' shop on Swan Street. However, the third incarnation of this now defunct pub is nowhere to be seen, at least not from street level, for it is hidden from view, underneath the Carillon Court shopping centre. Those who have been given permission to access it have been greeted by the ghostly sight of a pub frozen in time, where half-empty beer glasses remain on the tables, and Romanesque frescos on the walls. There is always speculation that the pub might once again open its doors.

Like other towns, Loughborough had many pubs named after royals, nobles and other influential people, or featuring their emblem. An example of this is The Duke of York on Nottingham Road. The Duke of York and Albany referred to in this pub name would probably be Frederick, given that the pub was in existence prior to 1822. He was the

second son of George III and held the dukedom from 1784 until his death at the London home of the Duke of Rutland in 1827. It was Frederick who was the subject of the rhyme 'The Grand Old Duke of York'. Another example is The Prince of Wales on Church Gate, which opened before 1863. This is possibly named after Albert Edward, oldest son of Queen Victoria and Prince Albert, and Prince of Wales from 1841. Emblems represented in the pubs of Loughborough include the Blue Boar on The Rushes, after Richard III; the White Hart on Church Gate, after Richard II; The Black Horse on High Street/Wood Gate, after Dick Turpin; and The Lord Nelson on Market Place. Of these pubs, only the White Hart remains today.

As well as recognising figures of national importance, influential locals are also remembered in pub names. An example of this is the Paget Arms, situated on the corner of Oxford Street and Paget Street, which honours the Paget family, who once owned the land the pub stands on. The family also provided land for local industry and housing, particularly for the firm of Messengers, which had houses built for its managers and workers between Derby Road and Ashby Road, known locally as the 'Messenger Village'.

Many towns and villages would have had people engaged in certain occupations and trades, like blacksmiths, and these were commonly reflected in pub names. Such occupational names appear in Loughborough and include the Blacksmiths Arms (Wards End), and the Coopers Arms (Barrow Street). More localised occupational pub names often reflect the importance of the woollen trade to Loughborough, such as the Bishop Blaize

The Royal Oak.

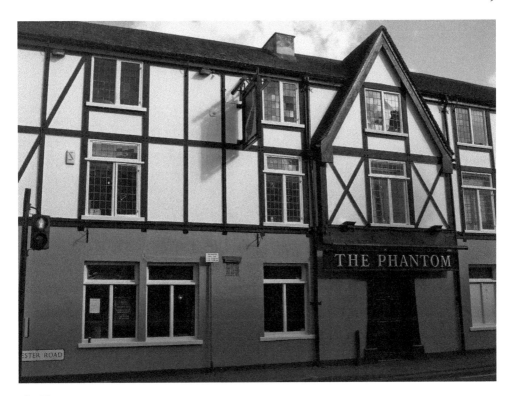

The Phantom.

(Wood Gate), or the Golden Fleece (Cattle Market/Granby Street). The Blacksmiths Arms continues as the Blacksmiths, while the Golden Fleece is now a café, but there is no longer a Coopers Arms nor a Bishop Blaize in town.

Some pub names reflect the sporting activity that took place in the locality. In Loughborough, although there was once a pub called the Cricket Players Arms (Cattle Market) and one called the Greyhound (Nottingham Road), most of the sporting pub names pertain to the sports of fox hunting and shooting, as Leicestershire is renowned for such sports. The nearby Quorn Hunt, to which Prince Charles has been a regular visitor, used to meet in the Loughborough Market Place on Boxing Day. Founded in 1696, it took its name from the village where the hunt dogs were kennelled, and is reputedly the oldest hunt in the country. Some of the Loughborough pubs honouring these sports were The Fox and Hounds (Wellington Street) and the Dog and Pheasant (Nottingham Road) – both now long gone.

Other signs are clearly related to the area, while at the same time being quite common across the land; for example, Loughborough still has a Boat Inn on the side of the Grand Union Canal. The Charnwood Forest Railway Inn (The Rushes), the Railway Inn (Nottingham Road) the Station Hotel (Derby Road) and the Great Central Hotel (Great Central Road) are all indicative of the local area. Each of these pubs was situated next to, or near, one of the three railways stations that were once in the town. The Beacon is a more specifically local name as it reflects the direction of a local landmark, Beacon Hill.

The Paget Arms, named for the Paget family.

The Blacksmiths, an occupational name.

Additionally, evidence of the brewery associated with a number of establishments can still be found around the town, if you know where to look. The Station Hotel, at the junction of Derby Road and Station Street, is now a funeral parlour. In 2005 the hotel was tied to the Burtonwood Brewery, a firm that had been in existence since 1867, but at the time was owned by the Wolverhampton & Dudley Breweries. Later, in 2005, it was sold to Jennings Brothers, who renamed the brewery Marstons plc the following year. However, The Station Hotel was originally tied to the brewery James Eadie Ltd, of Burton upon Trent. This was begun by Scotsman James Eadie in 1864, twenty-four years after he had moved from Scotland to Burton to work with his uncle in the tea-broking business. Eadie's was reputedly the first brewery to operate tied pubs. Evidence of The Station Hotel once being associated with the James Eadie brewery can be seen on the Station Street side of the building. High up between the first-floor windows, tucked into the start of the external chimney, the initials 'J E' can be seen on a decorative plaque.

DID YOU KNOW?
The Three Nuns was once the Three Tuns. In 1881 William George Dimock Fletcher, a curate in Oxford, who had at one time resided in Loughborough, referred in his writings to a pub in the town called the Three Tuns. A tun was a very large cask used to store beer or wine, and formed part of the arms of the Vintners' Company, one of the twelve great livery companies of the City of London. Apparently, the pub was accidentally renamed!

Closer to the town centre, on Biggin Street, stands the former Unicorn pub, which in 2018 was converted into a sports bar called Champs. The original building opened before 1828, but was replaced by the current building sometime after 1837. At the time of the opening of the second building, the pub was associated with the Bass, Ratcliffe & Gretton brewery company. The brewery was originally created and run by members of the Bass family, who were joined by John Ratcliff in 1796 and by John Gretton in 1835. Evidence of the pub's association with the Bass, Ratcliff & Gretton brewery is found on the side wall of the building in the form of the Bass logo, a high relief diamond shape.

Offilers Ales, a Derbyshire brewery, also had a presence in Loughborough. What is now The Orange Tree on Wards End was previously known as The Wheatsheaf, and at the time was tied to the brewery, as was The Blue Boar on Swan Street, now replaced by a shopping centre. Another Offilers pub, The Blackbird, now replaced by flats, was built in 1959 to provide refreshments and a social venue for inhabitants of the new housing estate nearby. The Wheatsheaf had engraved windows showing its affiliation, while The Peacock Inn on Factory Street, a pub associated with local knitting machine inventor William Cotton, still bears the engraved windows associated with the Offilers Brewery.

Evidence of Offilers beers being on sale in local off-licences can be seen in the ghost sign on the building on the corner of William Street and Curzon Street. This property,

The James Eadie affiliation.

The Bass affiliation.

situated as it is in the midst of a Victorian development, is typical of the local corner shop of that era. A 'corner shop' not only because it is on the corner of the meeting of two streets, but also because the entrance is accessed via a step up to the door that is effectively cut out of the corner of the building.

Another livery, that of Home Ales, is kept alive on the building that was once the Stag and Pheasant on Nottingham Road. The brewery was registered in 1890, having taken over that of James Robinson, and was itself taken over by Scottish and Newcastle in 1986 before closing in 1996. The Stag and Pheasant closed as a pub in 1962, but the ghost of the Home Ales brewery, green writing on a cream background, is still clearly visible on the side of the building, peeping out over the top of neighbouring properties.

Other pubs take their name from the location in which they are to be found or from what might have been on that particular site previously. An example of this is The Amber Rooms on The Rushes. The Rushes joins with Swan Street at one end and Derby Road at the other, and is now home to a modern twenty-first-century shopping

Offilers windows at The Peacock.

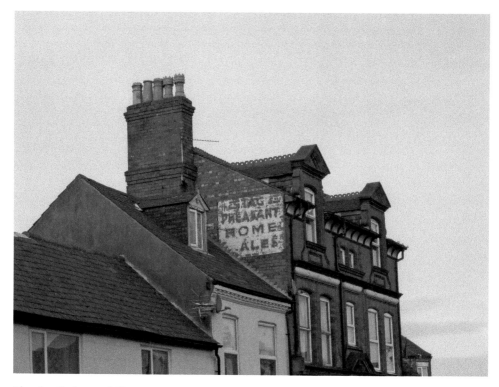

The ghostly Stag and Pheasant.

centre. The land had at one time been occupied by the Electricity Works, which opened in 1904, and was later enlarged. A row of old cottages and a lodging house called the Rising Sun were demolished to make way for the Borough Electricity Department Offices, and these in turn were demolished in 1990 to enable the area to be redeveloped into the shopping centre.

Not only are The Amber Rooms situated on the former site of the Electricity Works, but they are also named after electricity, for the very word comes from the Greek word *elekton*, which means 'amber'. The ancient Greeks discovered that when amber is rubbed it attracts particles, and modern electricity developed from this knowledge.

But, it's not just pub names that are significant...

Streets

With the need for more homes in which to house the country's burgeoning population, lots of pockets of development have been springing up in and around Loughborough recently. With this development comes an opportunity to remember the town's history, its inhabitants and its historically important events and locations through the meaningful naming of the new streets. What can the names of these and older streets tell us about Loughborough's past?

According to the expert toponymist and onomastician Adrian Room, street names can be fairly easily categorised and generally fall under a number of types: Roman roads and

ancient ways; self-descriptive; field and water (animal, bird and plant-related names may have originated as field names); directional; religious; trading, occupational and national; names of buildings and structures; bridge names; names from inns; names of personal origin; commemorative and propitious names; and more general thematic groups.

Room discusses some of the street names of Loughborough specifically, under his types outlined above, but makes no mention of Loughborough's older street names – those ending in 'gate'. The term 'gate' originates from the Viking *gatte*, meaning 'way'. At one time Loughborough had five of these: Baxter Gate, Church Gate, High Gate, Pinfold Gate and Wood Gate. High Gate has since become High Street, but the others retain their original names. The presence of these gates shows that during the period of Viking rule, Loughborough was a planned town rather than an ad hoc development.

Packhorse Lane is a self-descriptive name, so called because it was on the main route that passed through from Leicester and Nottingham during times when packhorses were used to transport goods, like wool, between the north and the south. Field and water names include Fennel Street, possibly a field name, or simply an area where fennel grew profusely; The Coneries, which refers to an area of former rabbit warrens; Meadow Lane, which comes from a field name (the Big Meadow, known since 2012 as the Coronation Meadow and one of a few surviving Lammas meadows in the UK); and Swan Street, which is named after a nearby swannery.

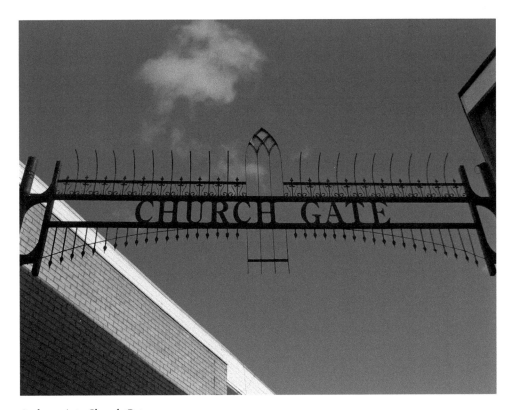

Archway into Church Gate.

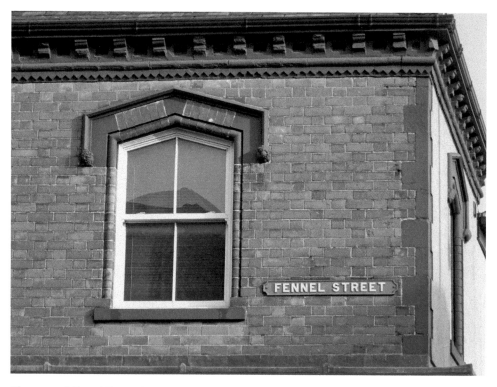

Blue enamel Fennel Street sign.

Directional names in Loughborough include Beacon Road, which leads to the historic hilltop, Beacon Hill in Charnwood Forest; Outwoods Road, which leads to The Outwoods ancient woodland; Dead Lane (although no longer extant), which allegedly led to the site of a burial place for victims of the plague in the 1600s; and Moor Lane and Little Moor Lane, which lead to the Loughborough Moors.

According to Room, Priory Road is a religious name commemorating the nearby ruin of Ulverscroft Abbey, as is the more specific Ulverscroft Road. Steeple Row is named for the nearby parish church (now known as All Saints with Holy Trinity), as the word 'steeple' can refer to a tower without a spire, which reflects Loughborough's parish church. Rectory Place reflects the location of the former rectory associated with the parish church.

Occupational street names are harder to find in Loughborough: older occupations common to the area include framework knitting, needle making, smithying, boatworking and so on. A recent reflection of these occupations is found in housing called The Needleworks, built on the site of one of Grudging's needle-making factories. Another recent addition to the streets of Loughborough is Wheel Tappers Way, which is situated close to the former Charnwood Forest Railway; however, the new Wheeltapper pub is on Wood Gate in the centre of town.

At one time Loughborough's racecourse was at the Lammas Meadow, but moved towards Derby Road, before eventually closing. Saddlers Close might be an occupational name, as it (and Racecourse Mews) are situated on the site of the more recent racecourse.

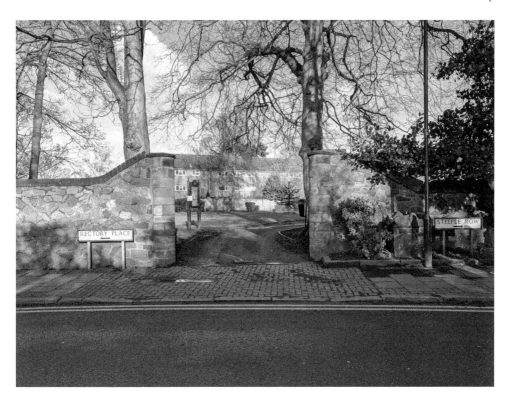

Above: Rectory Place, entrance to the Old Rectory, and Steeple Row.

Right: The Needleworks, named after the former needle-making factory.

Streets named after buildings and structures sometimes take their name from a relatively recent large house. This is the case with Burleigh Road, which reflects the name of the seventeenth-century Burleigh Hall that was demolished in the early 1960s. Similarly, Garendon Road (referred to by Room as 'Garendon Street') and other streets bearing the Garendon name, are named for Garendon Hall, the former home of the De Lisle family, which was demolished in 1964 – the house was on the estate that was to be severed in half by the M1.

DID YOU KNOW?
No. 77 Park Road was once called Fearon House and was the home of William Simpson Hepworth and his wife Olive. In 1904 Hepworth joined the Henry Wills printing operation in Angel Yard, off Market Place. The firm was still producing street directories, and it wasn't until 1914 that they published what became the first in a very long series of books for children – Ladybird Books.

Stonebow Bridge on the Garendon estate gives its name to Stonebow Close and the local school. Other bridge names include the obvious Bridge Street, Swingbridge Road and Chainbridge Close – the latter two being bridges over the canal.

What Room does not mention, however, are Loughborough road names that may have been taken from those of inns or public houses. One such notable name is Angel Yard. Today this is more of a passageway between the Market Place and a shopping centre, but in the early to late 1800s this yard would have opened off the Market Place and would have contained warehouses or other commercial premises. It was named after the Angel Inn, which was a substantial brick property fronting onto Market Place, and had stables and gardens behind. There was also a yard with malting rooms and pigsties. In the late 1800s Henry Wills had part of his printing works in this yard, and it was from here that the first ever Ladybird Book was published.

Local people are also commemorated in some of Loughborough's street names. Possibly the earliest of these is Thomas Burton, a wealthy wool merchant and benefactor to the town. His name lives on in Burton Street as well as in Burton Walks, a public walkway through the grounds of Loughborough Grammar School. Hastings Street remembers the Hastings family, who were lords of the manor. William Hickling, a seventeenth-century benefactor is remembered through Hickling Court, and local benefactor John Storer, who died in 1713, is remembered in Storer Road and in John Storer House, a community centre on Ward's End.

The agricultural and animal-breeding pioneer Robert Bakewell, who lived and worked in Dishley Grange, is commemorated in the nearby Bakewell Road. Archdeacon Henry Fearon, rector of Loughborough and responsible for ensuring the town was provided with a piped clean water supply, is remembered in Fearon Street and by a fountain in the Market Place.

Right: Angel Yard, formerly home to Ladybird Books.

Below: Hastings Street, named for the lords of the manor.

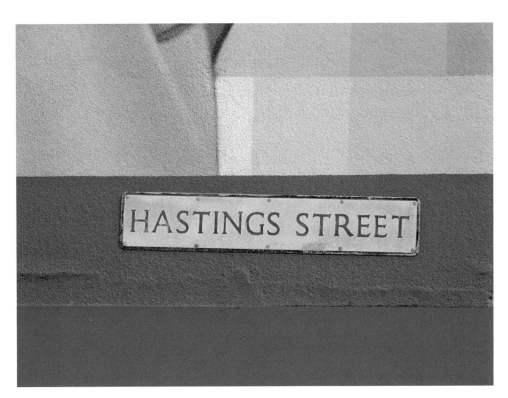

Local companies are remembered in many Loughborough street names, including Ladybird Close, Morris Close and Messenger Close. Local people and families are also remembered: Middleton Place is named after the banking family of Middleton; Burder Street is named after Walter Chapman Burder, who was the owner of Messengers, a company involved in making glass houses and boiler and heating apparatus; and both Pulteney Avenue and Pulteney Road are named after Richard Pulteney, a physician and botanist who wrote the first English biography of Carl Linnaeus, the creator of the modern classification of organisms scheme.

Like most other towns and cities, Loughborough has streets commemorating royalty: Albert Street, Victoria Street, Albany Street, Arthur Street, William Street, York Road, Windsor Road, King Edward Road, and so on. However, the unusually named Albert Promenade has no such royal connections. 'Albert Prom', which is attractively tree-lined, was named after Albert Ball, the son of Nottingham-born Albert Ball. Albert Ball Snr bought the nearby Elms Estate, which was the former home of the prominent Warner family, who were local hosiers. Albert Ball Jr served in the Royal Flying Corps during the First World War and was awarded a posthumous Victoria Cross.

Other noble connections include Beaumont Road, Rutland Street and Hastings Street, the latter also being a local connection, as mentioned above. Other notable connections include Cobden Street, at the end of which is Cobden Street School. Both are likely named for Richard Cobden, who was one of the founding members of the Anti-Corn Law League

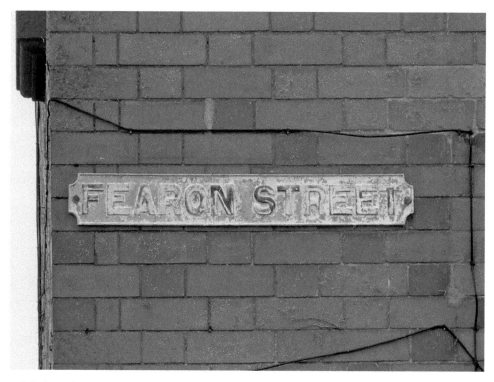

A faded sign honouring Revd Fearon.

Albert Promenade,
named for
Albert Ball Jr.

in 1838, and was the only person ever to beat Robert Peel in a debate in Parliament, which led to the repeal of the Corn Laws in 1846.

Room also makes mention of the more recent trend in commemorative names that celebrate cultural links that towns may have, often with a European country, and cites Epinal Way as one such example, as Loughborough is twinned with Epinal. Epinal Way is the ring road that avoids the town centre and runs from Leicester to Derby. The length, which runs through the garden city-style area of the Shelthorpe housing estate, is known as Ling Road, a name taken from the nearby cottage and farm of the same name, originally a field name.

The final category of street names identified by Room is that of general thematic names, often used for roads in close proximity to each other. Such street names include those named after artists, birds, country houses, flowers, lakes, poets, Shakespearean characters, trees etc. Loughborough has many examples of thematic naming: after birds – Wren

Celebrating cultural links with Epinal.

On the theme of stately homes.

Close, Kingfisher Way, Robin Mews, Moorhen Way and Goldfinch Close; after poets – Byron Street, Blake Drive, Milton Street etc. (Cleveland Road, which could be named after the seventeenth century metaphysical Loughborough poet John Cleveland, is in a different area of town from the other poet streets); after trees – Poplar Road, Maple Road, Sycamore Way, Acer Close etc.; and after the Lake District – Derwent Drive, Thirlmere Drive, Ambleside Close etc.

There are other thematically named groups of Loughborough streets whose meanings are rather less obvious than those named after trees or birds, and an understanding of these points to some interesting history. A relatively recent example of one such theme is that to be found on an estate on the edge of Loughborough, close to the hamlet of Woodthorpe and the estate of Beaumanor. Here are roads named Hugh Foss Drive, Leslie Yoxall Drive, Peter Twinn Drive, Peter Laslett Close, John Tiltman Drive, which are clearly named after people; the less obvious ones include Knox Drive, Boyle Drive, Aitken Way, Watkin Drive and Wilson Drive. The one that really cracks the code is Alan Turing Road, as these roads are named for people who were associated with the intelligence operations at Bletchley Park during the Second World War. Beaumanor Hall in Woodhouse, close to Loughborough, was a 'Y' listening station during that war, and had regular contact with people working in cryptography or cryptanalysis at Bletchley Park, many of whom went on to have distinguished careers.

Peter Laslett lectured at Cambridge University, reaching the position of Reader in Politics and History of Social Structure before retiring in 1983. He was a founder member of the University of the Third Age (U3A), of which there is a branch in Loughborough. Hugh Foss retired from GCHQ in 1953, and Leslie Yoxall in 1974. Dilly Knox, a graduate of King's College Cambridge, had been a codebreaker during the First World War, and died in 1943 while working at Bletchley Park as chief cryptographer. Edward Boyle went on to study at Christ Church College, Oxford, graduating in 1949. He inherited the baronetcy on his father's death in 1945 and was raised to the peerage on his retirement from parliament in 1970. Peter Twinn was the first person to read a German military Enigma message just before the secret operations moved from London to Bletchley Park in July 1939. He later became associated with institutions like the Royal Aircraft Establishment and the Natural Environment Research Council. In 1980 he was appointed a CBE, and he died in 2004. John Tiltman, an army officer in the First World War, was wounded and received the Military Cross. At Bletchley Park he was considered one of the best at his job, and in 1944 he was promoted to brigadier, a position from which he earned his nickname – The Brig. He died in 1982.

The exact origin of some road names on this estate is unclear. Was Watkin Drive named for Vernon Watkins, a Welsh poet who met his wife while they were both working at Bletchley Park? If so, why was it not Watkins' Drive? Wilson Drive may have been named for Angus Johnstone-Wilson, a codebreaker in the Naval section at Bletchley Park, or for Harold Bernard Willson, who was the first person to decrypt the Italian Navy Hagelin C-38 code machine. Aitken Way could refer to James Macrae Aitken, a championship chess player who worked at solving German Enigma messages. Or it could be for the New Zealand mathematician Alexander Craig Aitken, who also worked to decrypt the Enigma code during the Second World War.

Finally, perhaps the most well known of the Bletchley staff is Alan Turing, whose story was told in the recent film *The Imitation Game*, and who in 2019 was voted in a BBC television survey as the greatest person of the twentieth century. He is perhaps best known for being a cryptanalyst and designer of the Bombe (a mechanical device to help decipher Enigma messages) as well as being the head of Hut 8. Turing died a few days before his forty-second birthday.

DID YOU KNOW?
George Albert Hodson (1875–1938), son of George Hodson (1844–1907), who created the Hathern Station Brick and Terra Cotta Company (later known as Hathernware), attended Loughborough Grammar School. The family name is remembered in the school building of Hodson Hall. Edward Hands (1891–1933), solicitor, once lived in Burton Walks before moving to Castledine Street where his initials appear on the front of his house. Apparently, he could often be seen riding his hunting horse from a field near his home to his office on Market Street.

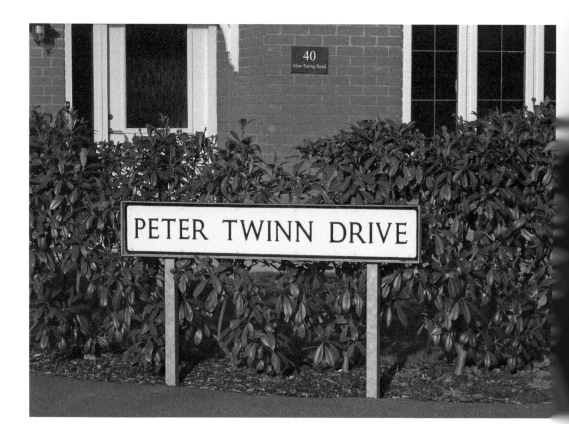

Peter Twinn and Alan Turing (slate nameplate) worked at Bletchley Park.

Other newer roads remember local people, like John Boden Way, on the very edge of town, which is accompanied by Lace Avenue and Bobbin Drive, and celebrates the town's industrial past. Thomas Cook Place is located close to the Midland Main Line station where Thomas Cook's outing arrived in 1841, of whom more later.

There are a number of unadopted residential streets in Loughborough, including Carington Street, Charley Drive and Deane Street. 'The Shanty' is a surprising name for a house on Castledine Street, another unadopted road. This house has now been renumbered as No. 72, and is soon to receive a Leicestershire green plaque to commemorate it as the home of Loughborough's active suffragettes.

Kathleen and Nora Corcoran were daughters of Dr Corcoran and joined the Women's Social and Political Union (WSPU). It is difficult to determine if it was the Corcoran sisters who were responsible for trying to start a fire in the nearby Red House, behind Castledine Street in Burton Walks, a property in the grounds of Loughborough Grammar School. Fire-starting equipment and a copy of *The Suffragette* were found at the scene of the start of the fire, but it's possible this evidence was planted. What is sure though is that the sisters went on to support the war effort as nurses, a fitting occupation for the time.

View along the private Castledine Street.

The physical street signs themselves can also be significant, and in Loughborough there are some wonderful signs still extant, which help to show the history of the town. Loughborough is lucky enough to be home to the UK's sole remaining bell foundry, and it is around the area where this is situated that the street signs are most informative. The iron foundry of John Jones, known as the Britannia Foundry, created cast-iron street signs that are easily identifiable as they carry the name of the foundry within the border of the sign.

Street signs can also be an indication of the age of the properties in the street. On Park Street, for example, there is an old blue street sign. There is a similar one on Sparrow Hill indicating the direction of the Market Place. These show that these areas have been established for many, many years. Of course, this doesn't always hold true because there are many occasions when old street signs are replaced by new ones.

House names and plaques can also point to the history of an area, and name tablets may reference historically significant events or names. The commemorative plaque on Shakespeare Street commends it for being the 'best decorated street' in the local newspaper's Coronation Competition of 1953. While Burleigh Road hosts some generic house names like Springfield Villa and Atlas Villas, with an explicit date of 1903, other properties show only a date. The date of 1801 on No. 20 Beacon Road indicates one of the oldest houses in this part of the town. On Fearon Street, Fearon Cottage honours the Revd Fearon; Beacon View House would at one time have had a fantastic view; and Fern and Ivy Villas are part of a thematic naming scheme.

Named after William Morris, the nineteenth-century architect/designer, the university hall of residence, known by students as Bill Mo, includes a house called Gimson. Ernest Gimson was a Leicester engineer and designer, and was influenced by Morris's work. With his associates, Ernest and Sidney Barnsley, all specialists in Arts and Crafts, Gimson moved to the Cotswolds. Here, Peter van der Waals and Edward Barnsley learned their craft, later becoming advisors to Loughborough College on the making of Arts and Crafts furniture. Could this Cotswold connection be the reason for the street close to Bill Mo being called Cotswold Close?

DID YOU KNOW?
It is not only street names that point to some of the history of the town. Willowbrook Retail Park on Derby Road is so named because it was built on the site where Willowbrook Coachbuilders had been. Many Willowbrook coaches at one time carried adverts for Offilers Nut Brown Ale.

Right: The way to Market Place.

Below: Shakespeare Street, once Loughborough's best-decorated street.

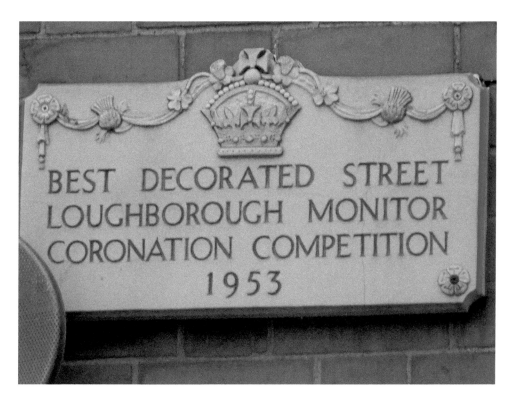

2. The Birds and the Bees, and the Horses to Boot!

Queen's Park

Created as a place where Victorian folk could take the fresh air and indulge in some exercise, the park was begun in 1897 on land previously part of the Island House estate. In celebration of Queen Victoria's Diamond Jubilee, the Queen's Memorial Baths was opened and an oak tree was planted on jubilee day itself (22 June). The official opening took place on 7 June 1899, and celebrations included a Punch and Judy show, dancing and a band recital. There was also a marquee erected across Granby Street, flags and bunting in the park itself, events in the Memorial Baths and refreshments available to all. At dusk the park was illuminated by a local engineering company, Brush.

During the period 1901 to 1916, further land was acquired for the park and the bandstand – for which a space had been left in the original park layout – was finally constructed. This celebrated the coronation of Edward VII and his queen, and was opened by Captain Burns-Hartopp, High Sheriff of Leicestershire. In 1908, the bandstand was moved as people stopping to listen were getting wet feet due to the many tributaries of the Wood Brook running under the park – even today parts of the grassy areas become waterlogged in heavy rain.

In 1923, a Carillon tower was erected as a memorial to those who fell during the First World War, and from 1948 onwards birds were introduced to the park.

Wildlife has always been a prominent feature of the park, and free-flying birds of many varieties – such as robins, sparrows, blackbirds and pigeons – can often be spotted in the trees or hopping along the flower beds. Caged birds provide extra interest for visitors. These aviaries in Queen's Park have moved around the park from time to time, but have been situated near the café for many years now. The ponds are frequented by moorhens, coots and mandarin ducks. There was a time, however, around the mid-1950s when the park was home to peacocks and penguins, golden and silver pheasants, and Gertie the Goose. A plan to introduce a pair of red flamingos did not come to fruition.

In 1992, local sculptor David Tarver created a children's maze using beige-coloured pavers set into red gravel. The prize at the centre is a beautiful sculpted swan with three cygnets, along with a small frog, all sitting under a wrought-iron gazebo. This maze was conceived in 1988 and commissioned in commemoration of the 100th anniversary of the incorporation of the borough.

Since 2007, Loughborough has taken part in the regional Britain in Bloom competition, often called simply 'In Bloom'. Queen's Park always looks spectacular, and exciting floral displays appear across the town.

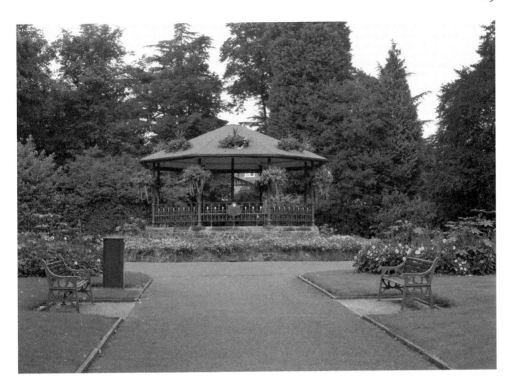

Above: Bandstand in Queen's Park.

Right: Swan maze and Carillon in Queen's Park.

The Legendary Horse Chestnut Tree

Opposite the petrol station and just past the cricket pitch and the lodge to the Garendon estate on the Ashby Road (A512), there is a row of horse chestnut trees. In April/May leaves begin to show on these trees. Look closely, however, and you will see that, as if by magic, one of them seems to leaf earlier than the others. There have been numerous theories put forward to explain this phenomenon. Could it be that a young, possibly expectant, woman took shelter from the wind and the rain while on a long journey and the tree sprouted leaves to protect her from the elements? Or is this where a monk from Garendon Abbey sheltered from the wind? Perhaps there is a spring directly under the roots of this specific tree? Or maybe it is simply an early leafing variety? Whatever the truth is, it's worth taking a trip along Ashby Road to see this beautiful tree, both before and after the surrounding trees have blossomed.

DID YOU KNOW?

The Manor House, now an Italian restaurant, on Sparrow Hill (meaning little hill) was part of the lord of the manor's estate and was constructed around 1477. The estate included parkland, a chapel, fishponds and rabbit warrens, as fish was a staple part of the diet (often consumed on a Friday) and rabbit meat was also popular. Today, the area where the rabbits were bred is known as The Coneries, a modern interpretation of the word 'coney warren' – a piece of land used for the breeding of rabbits.

The Cedar Tree

On the university campus, outside the Herbert Manzoni Building and opposite the Edward Herbert Building (EHB), stands an impressive cedar tree, often referred to as the 'Cedar of Lebanon'. In 1958, Loughborough College, as Loughborough University was then so called, bought the large Burleigh Hall and estate. The cedar tree is one of the few visible remains of the gardens of Burleigh Hall, and is reputed to be over 200 years old. This remarkable tree towers well above the former library and spreads its lower branches across the grassy area. However, in 1990, during a heavy snow storm, the weight of the snow that rested on the tree was so great that the top of the tree collapsed, nearly halving the height of it, and making it look like a leafy umbrella!

Hiding beneath the tree canopy are three sculptures called *The Watchers*, created by Lynn Chadwick and bought by the university in the mid-1960s. There are two other sets of companion sculptures: one set at Nordjyllands Kunstmuseum in Denmark, and another set on Alton estate in the London borough of Wandsworth.

The cedar tree is not the only tree of significance to Loughborough University. The university has developed an informal relationship with Woolsthorpe Manor, near Grantham, which was the home of Isaac Newton and is now owned by the National Trust. In March 2018, members of the university staff visited the manor and were given five

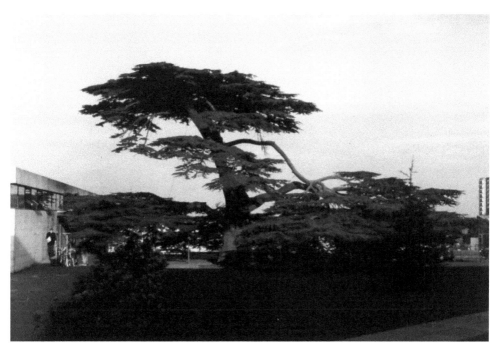

Cedar tree on the university campus in 1979.

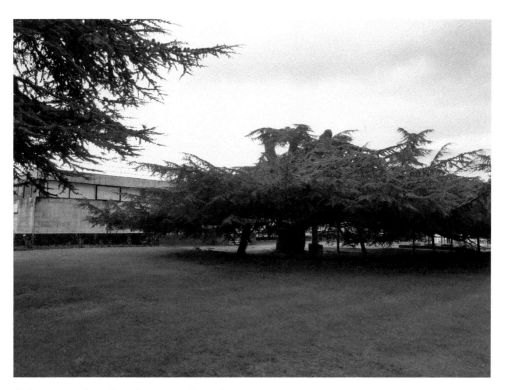

Cedar tree on the university campus in 2018.

cuttings from the famous apple tree associated with Isaac Newton's investigations into the laws of gravity. The tree is an old variety, known as the 'Flower of Kent', and is a focal point for those who visit Woolsthorpe. It is anticipated that once the cuttings have been attached to underground stems, after two years they will be planted around the university campus, as a reminder of Newton's contribution to the world of mathematics, with the aim of inspiring future generations of mathematicians.

At the Sign of the Peacock

A peacock in pride appears on the crest of the Manners family, the dukes of Rutland. At one time the 9th Duke, John Manners (1866–1940), was patron of Loughborough College. Rutland Hall, originally a hall of residence for students and built in 1932, was named in his honour. A peacock in pride also appears on the top right quarter of the shield on the gates at the original entrance to Rutland Hall, off Ashby Road, although this is now closed to traffic. In heraldry the peacock can symbolise authority, resurrection, immortality, beauty or pride of carriage, and the dukes of Rutland may have chosen it as their symbol for any of these reasons.

In 1966, Loughborough College was granted its royal charter, along with a coat of arms by the College of Arms, and so became a university. As Loughborough is situated within the former Anglo-Saxon kingdom of Mercia, the cross of Offa, a former King of Mercia, was chosen to be depicted on the shield. Perhaps of more significance locally, the university coat of arms includes a peacock as part of its crest.

The university coat of arms.

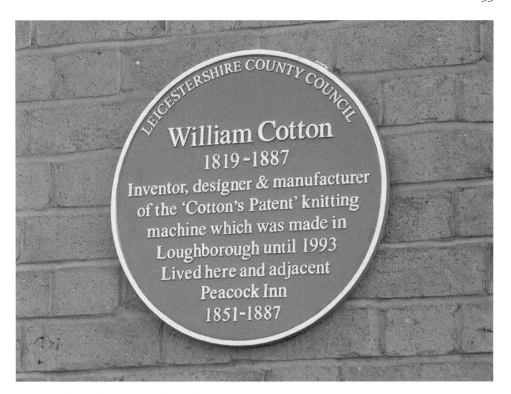

Heritage plaque honouring William Cotton.

On Factory Street, which is just off the Leicester Road, there is a pub called The Peacock Inn, which has been in existence since before 1854. As there was already a pub called the Marquess of Granby in the town, and also one named the Rutland Arms, both of which pre-dated The Peacock Inn, could this pub have been named in honour of the eldest son of the 3rd Duke of Rutland, John Manners, who was the Marquess of Granby and commander-in-chief of the forces in the 1700s? Or, since inns and public houses were often used as venues for auctions, inquests and hearings, perhaps The Peacock Inn is so called because of the supposed incorruptibility of the peacock's flesh, which gave rise to the popular oath 'by the peacock'? Whatever the answers to the above, The Peacock Inn remains a popular venue, and in February 2018 was the setting for a ceremony associated with the unveiling of a Leicestershire green plaque on the adjoining house in honour of William Cotton, a local industrialist.

Songster: Loughborough's Own Warhorse

Armistice Day, 11 November 2018, and the Market Place in Loughborough is full of people commemorating the end of the First World War, for this is where many Loughborough soldiers who were in the Leicestershire Yeomanry met before leaving for battle in 1914. Amid today's crowd is a life-sized model of a horse, his wire frame covered in poppies made by local children. But this is not just any old horse, this is Songster, Loughborough's very own warhorse.

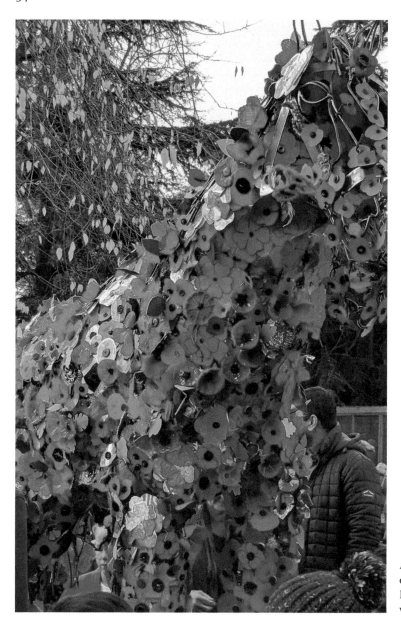

A commemoration of Songster, Loughborough's warhorse.

Until very recently, the story of Songster was not often told, his memory fading as those who knew and remembered him passed away, although there is a large model of a horse in the Yeomanry Room in the Carillon, which serves as a reminder. What better time than now to investigate the story of Songster?

Of Songster's birth and his early life, however, little is known. It appears he was a chestnut horse, born around 1900. Although originally deemed to be too old for war service, at age fourteen, in 1914 Songster was mobilised along with other horses and assembled in the Market Place with members of the Leicestershire Yeomanry. Early in the

conflict, Songster met his rider, Trooper Bert Main, who rode him for the duration of the war and the pair became great friends.

Luckily, both Songster and Bert survived the war, and Bert purchased Songster at an auction. Thus, Songster narrowly escaped being sold to a butcher, or as a beast of burden, and came to live on West Beacon Farm at Woodhouse Eaves. Along with Songster, Bert also bought Fenian, another warhorse from the Leicestershire Yeomanry, and the two horses lived together until Fenian died.

Fascinating stories of the Old Boot pub have been shared, particularly one about there being hoof marks on the wooden stairs, but how did they get there? Apparently, after Songster had returned safely from the First World War, he would climb the stairs of the Old Boot with Bert Main on his back, parade round the upper rooms and then carefully descend again, leaving hoof marks as he went!

Songster died early in 1940 and an obituary appeared in *The Times* on 17 January. He was buried on West Beacon Farm along with his medals. A new grave marker was installed in June 2018. Earlier, in May 2013, the Territorial Army had named one of their vehicles after Songster.

Loughborough's Own Racehorse: The Story of Sunloch

Sunloch was a Loughborough hunting horse owned and trained by Thomas Tyler of Gainsborough House. In 1914, at the age of eight, Sunloch was entered for the Grand National steeplechase at Aintree, ridden by Bill Smith and with starting odds of 100/6. Contemporary newspaper reports suggest Sunloch was an outsider who apparently knew nothing about steeplechasing, having been regularly ridden to hounds. Surprisingly, Sunloch won the race in a time of 9 minutes and 58.8 seconds, a very reasonable time and only 0.2 seconds slower than the 1852 winner, Miss Mowbray, the second of only thirteen mares ever to have won the race.

Sunloch had another attempt at the Grand National in 1919, but the jockey decided to withdraw him from the competition. Shortly afterwards Thomas Tyler sold Sunloch to Charles Aldridge. It was while in training for the 1920 Grand National event that Sunloch fell, breaking a fetlock. It is said Sunloch is buried on the exact spot where he fell, and one of his hooves, which were removed before his burial, is still owned by descendants of the groom who humanely dispatched him.

Today, Sunloch is commemorated by a prestigious Leicestershire green plaque attached to the front of Gainsborough House on Nottingham Road, the former home of Thomas Tyler.

The Shelthorpe Cottage Pony Incident

In November 1862, Mr Deane, the owner of Shelthorpe Cottage, along with his wife and Mr and Mrs Wilson, left the cottage in a pony phaeton and the pony pulling it escaped and ran away. As one of the carriage wheels broke, all except Mr Deane were thrown onto the road. The pony ran for a mile, all the way into the Market Place, before it was stopped. Dr Eddowes attended the injured persons. Mrs Wilson was quite seriously injured, but the others escaped with just bruises. Shelthorpe Cottage is now The Cedars Hotel, likely named after the large cedar tree in the front garden.

Leicestershire green plaque (far right) on Gainsborough House, home of Sunloch's trainer.

DID YOU KNOW?
There exists in the record office for Leicester, Leicestershire and Rutland an interesting old document that tells a sad story of a young boy of Loughborough: 'Roger Sheppard, sonne in lawe to Nicholas Wollandes was sleayne by a Lyones – whiche was brought, into the towne, to be seyne of such as would gyve money to see her. He was soore wounded in sondrey places and was buried the xxi daye of august 1579.' What a tragic way to die!

3. Look Up, Look Down, Look All Around

There are lots of traces of Loughborough's history scattered everywhere, and buildings throughout the town are peppered with clues pointing to interesting developments, inhabitants or events. Sometimes these clues are obvious, sometimes not. But we are often in too much of a hurry or too busy to notice them, and even when we do look up, down and around, do we really take the time to discover why something is there, or who put it there?

If buildings could talk they might tell us their history, but usually this requires a bit of detective work on our part. Secrets are often hidden behind images, logos, carvings...

It is evident from the text written on the parapet that the art deco building decorated in Hathernware, on Derby Road, near its junction with Alan Moss Road, was once a Co-operative grocery store. The Co-operative Society was formed in 1844 in Rochdale, but this building was erected in 1926, a time of much prosperity and improvement in Loughborough. So, where in Loughborough might there have been an earlier branch of the Co-operative, for there surely was one?

In the town centre, down on Wood Gate, next to the Organ Grinder pub (formerly the Pack Horse) there are beehives galore. We are not, however, looking for Beehive Lane, nor the Beehive car park, but rather a beehive carved in high relief in a stone tablet, mounted between the first-floor windows of the Laughing Buddha Chinese restaurant. The hive is populated by several bees, surrounded by the date 1865, and shows two hands performing a handshake above it. This is an important logo of the Co-operative movement. The beehive symbol was used by the organisation because of the similarity between the way bees co-operate to achieve and how those Rochdale pioneers co-operated with each other in the formation of what is now a national institution. This is a former Co-operative store. A similar high relief beehive can be seen on the former Co-operative building on Wide Street in Hathern.

In 1871, six years after the building was erected, George Dewbery, aged thirty-three, was the manager of these Co-operative stores on Wood Gate, where he lived with his wife Sarah and young son Frank. By 1901 Mrs Reeves was the manager, and the store continued to trade until the mid-1950s. Since then there have been Co-operative stores in various locations across the town, including Lansdowne Drive and now on Knightthorpe Road, on a site previously occupied by The Maltings pub, formerly known as The Gallant Knight. Prior to this, Knightthorpe Hall was on this spot – the gate piers and gates are still standing on the Epinal Way corner of the plot.

The Sock

Affectionately known as 'the Sockman', one might argue that given his prominent position at the head of Market Place, close to the Town Hall, and the amount and heatedness of the discussion his presence has generated, that he is hardly a secret. From

Former Co-op, Derby Road.

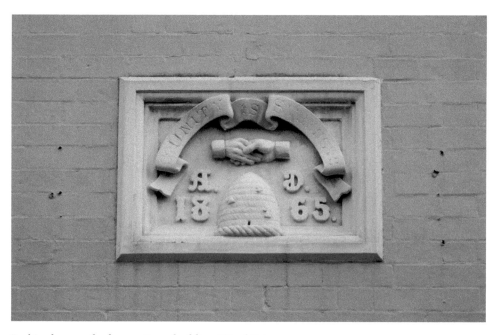

Beehive logo on the former Co-op building, Wood Gate.

his initial design and inception to his appearance in the centre of town, he has been a constant talking point, polarising local opinion – you either love him or hate him! He has been the destination for a flash mob, the starting point for the Sockman Dash (an event raising money for Sport Relief), subject to the admiration of retail guru Mary Portas, a Pokémon Go hotspot, a focal point for vigils and campaigns, and his besocked leg has been stroked innumerable times!

The story behind *The Sock*, and the Loughborough story it tells, is a great one. *The Sock* was unveiled in 1998 and owes his existence to the pedestrianisation of Market Place. Over the years Market Place had been open to two-way traffic, joining Cattle Market to the High Street, and a one-way parking area, as well as the site for the regular markets and the November fair. To celebrate the pedestrianisation of this area, the council wanted to install a piece of public art. They launched a competition in November 1996 to find an appropriate piece, and a variety of artists put forward proposals for artwork that would showcase Loughborough's history.

The entries received were evaluated and five pieces were short-listed. Models, drawings and descriptions of the five short-listed pieces were displayed in Market Place, and the public and a panel of experts were invited to comment and vote for one work. The selection panel assessed the practical and aesthetic merits of each work and chose a winner.

Artist Shona Kinloch submitted plans for a bronze statue of a man sitting on a bollard, wearing only a leaf and one sock. This statue was chosen by the panel for its artistic

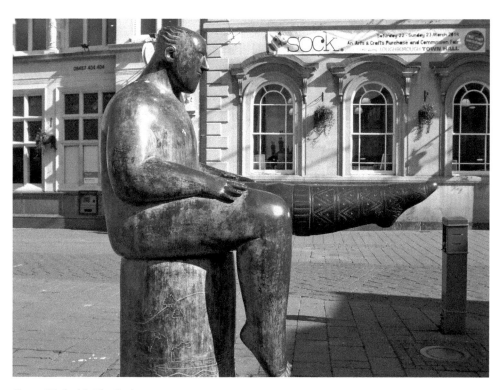

Shona Kinloch's *The Sock*.

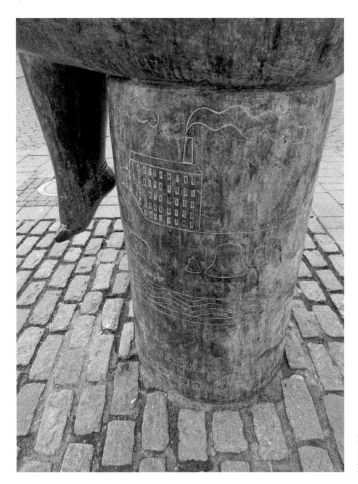

Pedastol of *The Sock* showing incised images of Loughborough's past.

quality, technical merit and durability, also for being the piece that best met the brief of representing Loughborough's history. *The Sock* was commissioned in August 1997 and unveiled at a ceremony on 11 April 1998. The man's outstretched leg, complete with a sock, hints at Loughborough's involvement in the hosiery industry.

The usual cry of the local tour guide is to 'look up', but here it is 'look down', for around his base, *The Sock* showcases more of the town's history. The incised images include bells, trains, sheep, hosiery factories, cranes, fairground rides, Towers hall of residence and the Carillon, to name but a few. These images are echoed in other artworks across town.

Murals

A relatively new leisure complex situated off Baxter Gate includes coffee shops, restaurants and a multiplex cinema. It's a lively and popular area that has been built on the site of the former Loughborough General Hospital. It has seen the renovation of nearby buildings, including the Grade II listed former nurses' home and doctor's surgery, which was originally opened as the Garton and Amatt Auction Mart, and is now a pizza restaurant.

The area is adorned with seating and flower beds, and during the Loogabarooga Festival it is home to a Ladybird Books bench. Towards the rear of the area is another of Loughborough's well-hidden secrets – a mural. Given its proximity to the cinema, this mural has been cleverly designed to depict scenes from iconic films through the ages. Not only that, alongside the cinematic images it also shows some icons of Loughborough, like the Carillon, the Great Central Railway and *The Sock*.

Like the coming of *The Sock*, the mural was born as the result of a competition, staged by the site developers, and local people were invited to submit a piece of artwork. The winning mural, which is cast in concrete and measures around 5 metres wide and 3 metres high, was created by artist Barry Bulsara. Appropriately, Bulsara was born in the hospital that previously occupied this site!

Looking up in the Devonshire Square area of the town one cannot fail to notice the mural painted by Wei Ong (Silent Hobo), to improve the look of the railing above the shops. The scenes depict local life, people, places and events. Another of the artist's paintings is rather more hidden, in Market Yard. *Lady Jane Grey* was painted live in the town centre, as a prototype and a chance for local people to see the artist in action and make suggestions for inclusion in the Devonshire Square mural.

Other murals are also popping up around the town, particularly in the Ashby Square area, where there are interesting paintings on the wall of the letting agency, a pizza restaurant, the exit of a car park and the hoardings surrounding the back of the shopping

Barry Bulsara's mural, Hospital Way.

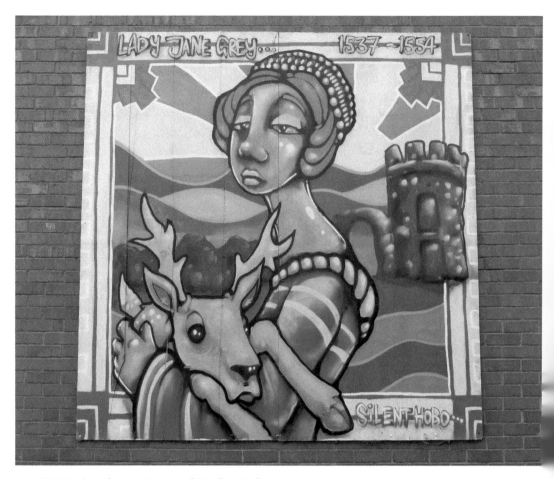

Wei Ong's *Lady Jane Grey* mural, Market Yard.

centre. Further along Ashby Road on a building at the road's junction with Hastings Street is a painting of a 'citrus lady'.

DID YOU KNOW?
A short time before the start of the annual Loogabarooga Festival of Illustrated Children's Literature, several specially commissioned Ladybird Book benches pop up around the town. These imaginative benches, shaped like an open book and decorated with text and drawings from original Ladybird books, provide a lovely place to sit and chat, and really are a talking point. Sometimes they can be found inside the Town Hall, or in Market Place or in the forecourt of the multiplex cinema, but there are always a couple in Queen's Park.

Mountsorrel Granite and Other Stone

You may not think the streets of Loughborough are paved with gold, but to a historian they most certainly are. Take, for example, the pink cobblestones that are at the entrance to the carriageway arch of No. 55 Sparrow Hill. This building was built as Parks Millwrights in 1854 and has workshops to the rear. The entrance is paved with local Mountsorrel granite – pink in colour due to the presence of iron. There are many other examples of the use of Mountsorrel granite throughout the town, including where the pavement meets the road in New Street, which leads into Queen's Park.

More poignantly, on Swan Street and Empress Road there is a Mountsorrel granite cross set into the tarmac. These commemorate the landing sites of Zeppelin bombs that fell on Loughborough on the night of 31 January 1916. During the raids ten people were killed. It is thought the airships were attracted by lights in a nearby factory, so one would think the town's inhabitants would be more observant in the future, but by 1 March of that same year eight people from Loughborough were charged with having lights blazing out!

A distinctly different type of stone is used in the Granby Street car park to highlight an area, just before the entry barriers, and near the pay and display machine. You may wonder why this area is so paved and why it hasn't become part of the car park itself because it does make for a tricky entrance. The Granby Street car park is on the site of the former cattle market and the area has been preserved to show where the animals would have been paraded around the ring to prospective purchasers.

Mountsorrel granite cobbles.

Mountsorrel granite cross commemorating the landing place of a Zeppelin bomb.

Railings

In the words of Lea Cetera, an artist from New York, 'Railings are ubiquitous outdoor objects, designed to ergonomic standard measurements for ease of use,' but there can also be an element of fun to this practicality. From early iron railings to modern-day stainless steel ones, there's a whole host of interesting railings scattered around Loughborough, if you know where to look, and these reflect not only developments in materials, but also provide some history.

A house on Burton Street, called Holly Bank, has ironwork gates appropriately replete with holly leaves, reflecting the name of the property. This property appears on the 1880 first edition of the 25-inch Ordnance Survey map. Its inhabitants have included the Misses Wragg (sisters living on their own means), a member of the local printing family of Corah, a Dr Broadbent, and today it is also home to a doctor.

When the schoolrooms of the Warner School on School Street were demolished, the headteacher's accommodation was retained and refurbished. Finding itself alone and now situated on the corner of Pinfold Gate and the new Jubilee Way, the property has some new gates onto its short driveway, which includes tools such as spanners and pliers in its fun design. Decorative archways have also been erected at the entrance to Pinfold Gate and on nearby School Street.

The Hastings coat of arms includes a maunch and a lion, both of which are to be found on the railings of some relatively new properties built at the junction of Sparrow

Gates on Holly Bank.

Hill and The Coneries, just down from the Manor House where Henry Hastings (*c.* 1609–67) was born.

Trained at Nottingham Trent University, artist Hilary Cartmel works mostly in metal. Her stainless-steel railings adorn the entrance to Charnwood Museum, the enticing faces drawing the visitor in. Once inside the former Memorial Baths, visitors can walk over a glass-covered dinosaur, but the remains of the swimming pool are hidden beneath the floor of the museum.

A length of railing along Derby Road outside a development of new properties features a blue falcon. This is an interesting and significant choice of motif, for this was previously the site of Henry Hughes' Falcon Works. This was established prior to 1854, becoming part of the Brush Electrical Engineering Group in 1889. Brush Electrical Machines is now a renowned international company, based in Loughborough, producing electrical generators for gas and steam turbines.

Joseph Griggs, the first mayor of Loughborough during 1888, the year of incorporation, lived in Mountfields House. A century later, designer Christopher Campbell created and installed galvanised steel, grey-painted railings. Children from the nearby Mountfields Lodge School and several professionals were involved in developing ideas for the fencing, which resulted in a structure that looks like swaying trees, their branches and leaves decorated with brass animals created by the children.

Charnwood Museum and its railings.

Site of the former Falcon Works.

Fearon Fountain

In the Market Place is a stone fountain known as the Fearon Fountain. It was given by the Revd Henry Fearon to celebrate the coming of the first clean water supply to the town, a success that was largely down to his persuasive arguments. The fountain was unveiled in 1870 and since then has been renovated several times: in the 1980s by local sculptor David Tarver, in 2012 and again in 2018.

Set into the paving stones around the base of the fountain are a series of plaques celebrating Loughborough's relationship with a variety of other towns, including Epinal (France), Schwäbisch Hall (Germany), Gembloux (Belguim), Zamość (Poland) and Bhavnagar (India).

Town Hall Clock

The original Corn Exchange (now the Town Hall), which was erected in 1855, did not have a clock on the exterior. This was added in 1880 after being donated by the MP for North Leicestershire, Edward Basil Farnham, of Quorn House. The original clock bell was cast by Taylor's the bell founders in 1879. They recast it in 1929 and it was rehung in 1930. In 2018, after a couple of years of silence, the clock bell was restored, and in February of that year it again began to chime – but only during the daytime, to avoid annoying nearby neighbours during the night.

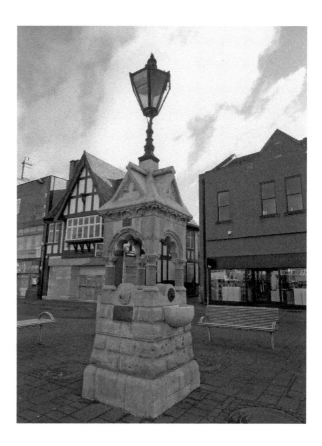

Fearon Fountain.

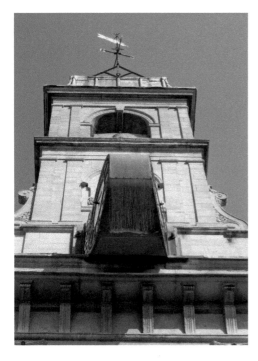

The angled Town Hall clock.

Many towns have clocks very similar to that on the Town Hall, but Loughborough's is special. Standing underneath the clock, it is noticeable that the faces bow out, which ensures the clock face can be seen easily from both ends of the town.

Pinau Statue: Boy with Thorn

Outside the public library is a statue of a boy sitting and removing a thorn from his foot. This was a gift to the town from Epinal in France and was erected in 1957 to celebrate the twinning relationship that had been created in 1956. The statue is a copy of a Greco-Roman Hellenistic bronze sculpture, often known as *Spinario* or *Fedele*. Over the years copies of this statue have been regarded as a suitable ambassadorial gift from one nation to another. On the front of the pedestal is the year '1957' and the intertwined initials 'E L'. On one side is a commemorative plaque that explains Epinal also has a copy of this statue.

DID YOU KNOW?
Loughborough's Pinau statue was stolen in the 1980s, but luckily was retrieved from the River Ouse at Goole a couple of years later. By chance a man living in Goole, knowing nothing of its history, showed a picture of it to his parents, who happened to live in Loughborough. Recognising it, the family ensured the statue was returned to Loughborough and the damages were repaired by David Tarver. The town of Epinal, who gave the statue to the town, also gave one to Schwäbisch Hall, a town in Germany with which both Loughborough and Epinal are twinned.

Signaler

Anyone shopping in The Rushes shopping complex is bound to have noticed the apparently rusty statue at its centre and is even likely to have walked over its plinth. Oh, that they had stopped to consider the significance of this statue and its name, for both hint at Loughborough's past. Created by John Atkin, Reader in Fine Art at Loughborough University, the human-like form of the statue is made up of garment templates, a reflection of Loughborough's industrial past, and is made of weathering steel (sometimes known as COR-ten or corten) and stainless steel, placed on a concrete base. As it is specifically designed to weather, it will develop a colour based on the atmospheric conditions in which it is situated, so in this respect the *Signaler* will be truly unique to Loughborough.

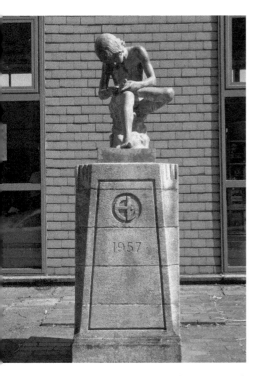 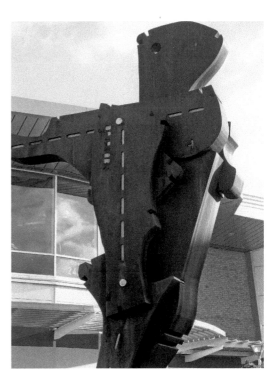

Above left: The *Pinau Statue*, a gift from Epinal.

Above right: John Atkin's *Signaler* nods to the garment trade.

4. Loughborough Firms

Hosiery and Related Companies

Like other towns, through the ages Loughborough has had its fair share of iron foundries and brick works. It has also been home to several iconic companies, like Ladybird Books and Taylors Bellfounders. More recently, Loughborough has been the location for coachbuilders, pharmaceutical and other companies, but in the eighteenth, nineteenth and even into the twentieth centuries, hosiery companies were the most prevalent industry in the town.

The names of many hosiery companies, both those that originated in Loughborough and those that were simply branches of companies from nearby towns, will be familiar to many of the people of Loughborough. Early firms included I. & R. Morley and Heathcoat's (variously named 'Heathcoat, Lacy and Boden' and 'Heathcoat and Boden'), although the latter moved to lace production.

A trade directory of 1846 listed hosiery firms like: William Pearson; John & George Cooke; William Dean; Luke Gimson; John Leavesley; Paget and White; Robert Ratcliffe;

Former I. & R. Morley hosiery factory.

Warner, Cartwright and Warner; and John Watson. Many of these firms closed or changed ownership so also changed name, becoming, for example, Cartwright and Warner, Towles, F. and W. E. White, the Nottingham Manufacturing Company, and so on. By 1863 a local trade directory listed twenty hosiery companies in Loughborough. Companies involved in related trades were also situated in the town. These included dye work companies like those of Clarke's Dye Works, and Godkin & Son, and needle-making companies like Hammonds and Grudgings.

Taylor's Bellfounders

The existence of Taylor's bell foundry on Freehold Street is hardly a secret, but what may be less well known is that following the relatively recent closure (2017) of the Whitechapel bell foundry in London, Taylor's are now not only the sole remaining bell foundry in the UK, but also the largest in the world. The extent to which Taylor's bells can be found, not just in the UK but across the globe, is also probably not such a well-known fact.

Taylor's have had a presence in Loughborough since 1839, when John Taylor came to the town from Oxford to recast the bells of the parish church. He initially worked from a yard at the rear of the Pack Horse pub on Pack Horse Lane, but on John's death in 1858 his son purchased land around Freehold Street on which to build a permanent factory, which is still in use today.

The same year that building work began on St Peter's Church on Storer Road, Loughborough, work was completed on Truro Cathedral, which opened with a service of dedication on 21 June 1910. Designed by the notable architect John Loughborough Pearson, it housed a peal of ten bells made by Taylor's, which were hung in two tiers and dedicated to various Cornish and Celtic saints. The peal of bells was heard for the first time at the dedication service. The sound was so loud that mattresses were used to muffle and mellow the sound, so that workers in the nearby telephone exchange could hear the people who were calling them – such is the strength and power of a Taylor's bell!

The York Minster Society of Change Ringers consider Taylor's to be the 'Rolls-Royce' of bell founders. Today, the work of the bell founders is very similar to that of the nineteenth-century bell founder, and there is an opportunity to see the foundry in action on a guided tour, as well as visit their informative museum.

DID YOU KNOW?
The Great Paul bell in St Paul's Cathedral, London, was cast by Taylor's between 1871 and 1881. At over 10 feet high, 11 feet in diameter and weighing over 16 1/2 tons, it is the largest ringing bell to be cast in England. When completed, the bell was displayed in the factory and viewed by many local folks, before being transported to London on a special trolley between two agricultural steam traction engines – a journey that took eleven days! Today, the cast of the bell is on display in Queen's Park, Loughborough.

Taylor's Bellfounders.

Foundries

Thomas Goode Messenger of Messengers, John William Taylor of Taylor's the bell founders and Edwin Cook were once partners in the Star Foundry Works. This business partnership commenced in 1867, but was short-lived as Messenger withdrew in July 1875. When Walter Chapman Burder took over Messengers he moved the company to a location now at the end of Cumberland Road and established the company's iron foundry.

Edwin Cook's Star Foundry was situated on the site that now houses the Royal Mail Loughborough Delivery Office on Nottingham Road. The workhouse had been sited here, but moved to Derby Road in 1838 when it became the Union Workhouse, and the site subsequently had a variety of uses. The Star Foundry Co. Ltd announced in July 1867 that they had become the proprietors of what was described in contemporary newspapers as 'large and commodious premises'. By erecting a foundry and installing machinery, the site was made suitable for the business of brass and iron founding.

Foundries called 'Britannia' existed in many parts of the country. The Britannia Foundry in Derby was taken over in 1848 by Glaswegian Andrew Handyside. His company made bridges, railway station roofs and ornamental ironwork like lamp standards and fountains. Creating their first postbox in 1853, Britannia (Derby) were contracted from 1879 to supply postboxes across the country until the early twentieth century, and there is an example of one of these in Loughborough on Forest Road, which bears the royal cypher 'VR'.

The Britannia Ironworks in Leicester and Loughborough were both situated near the canal – around 1809 Loughborough's was by the Meadow Lane canal bridge, on the Leicester Navigation. In 1880, at the time of a name change to Britannia Foundry, the firm was run by John Jones & Sons, who lived in Britannia House on Meadow Lane and had cottages on Meadow Lane, called Britannia Terrace, built for his workers.

By 1911 the firm was involved in iron moulding and manufacturing equipment like hot water engines. Although no longer in existence, evidence of the work of John Jones and the Britannia Iron Foundry and other local foundries can be found around the town, if one looks carefully.

Drain and manhole covers made by John Jones, Ironfounders hide in Loughborough cemetery. Now painted a vibrant blue, the iron railings created by Beeby & Henton are at the Burton Street entrance to the Endowed Schools. As we already know, cast-iron street signs – such as Freehold Street and Cobden Street – created in 1902 are embossed with the name 'J. Jones & Sons Ltd Loboro'. Radiators in the Church of All Saints with Holy Trinity bear the name 'Messenger & Co Ltd Loboro'. Work from Edwin Cook's Star Foundry is still evident in the cast-iron stops that are in place to prevent vehicle wheels damaging bricks at the bottom of gateposts and door frames on Park Road. On local streets like Middleton Place, where the first houses were built between 1881 and 1889, drain covers bear the foundry marks 'E Cook & Co Loughboro'.

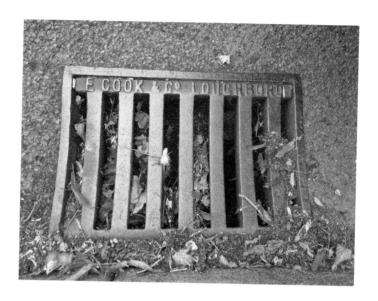

Drain cover by
Edwin Cook.

Street sign by John Jones.

Hardy and Padmore lamp in Queen's Park.

Not all ironwork found in the town gives information on its manufacturers so readily. The ornate birdcage entrance to Loughborough cemetery from the footpath is a beautifully designed structure that is complemented by the iron railings surrounding the cemetery, but no maker's marks are visible. The cast-iron grave plot markers are also anonymous works of art. There are no obvious markings to indicate where the archways on Pinfold Gate and School Street were made.

Nor are there any on the archway entrance at the bottom of Church Gate, which was installed to celebrate the first Loughborough street to be pedestrianised. During the late 1920s to early 1930s, many of the town centre streets were widened: Church Gate was not, and so retained its original medieval width of 18 feet. In 1890, it was the first local street to be tarmacked.

Not all ironwork was produced locally. A beautifully decorated town centre street lamp was found languishing near the Great Central Railway (GCR). Rescued and renovated it was placed appropriately in Queen's Park. It was made by the Worcestershire firm of Hardy and Padmore, who made street furniture, gas engines, boot removers and doorstops.

Tucker Brickmakers

In 1868, a new London railway station opened, showcasing the best of construction materials from the Midlands. Engineered by William Henry Barlow and Roland Marsh Ordish, St Pancras station was built by the Midland Railway to connect London to many major English cities. The Victorian Gothic design for the hotel and station accommodation was by the renowned Sir George Gilbert Scott. The ironwork was made by the Derbyshire firm Butterley Iron Company, the majority of the 60 million bricks used in the building were manufactured by Nottingham firm, Edward Gripper, and the mortar was also produced in

Above left: Tucker's bricks atop a gatepost.

Above right: Tranquil Charnwood Water, once a clay pit.

the Midlands. Such was the demand for brick that Edward Gripper's firm were unable to keep up, and while disappointing for the Nottingham company, this proved to be the perfect opportunity for the Loughborough firm of Tucker, who were able to provide the additional bricks. Butterley Iron Company also made bricks and it was they who acquired Tucker of Loughborough in 1964, keeping the firm open until 1967, but liquidating it in 1979.

Evidence of Tucker's brickworks can still be seen around Loughborough. Charnwood Water, formerly a Tucker's clay pit, is now filled with water and is a haven for birds, a great place for anglers, a perfect place for model boats and ideal for walkers. There is a pond off Epinal Way, close to Tucker's William Street brickworks which is now a haven for wildlife. The site currently occupied by a large supermarket between Park Road and Beacon Road was also used by Tucker before it was transferred to the local building firm William Davis. There is a pair of Tucker's bricks making the top row of a gatepost in a former house on Granby Street.

Ladybird Books
In the second half of the nineteenth century Henry Wills ran a bookshop in Market Place, selling newspapers and magazines, and ran a lending library. By the 1870s Wills had purchased the Angel Press and diversified, printing local trade and street directories, and the local newspaper, the *Loughborough Echo*. At that time there were several printing firms in the town, likely because the town had recently benefitted from a piped clean water supply.

At the turn of the nineteenth century, William Hepworth joined the business and in 1914 the company published a book for children, which was to become the first of the Ladybird Books, although in a slightly larger format. The Ladybird logo was later registered and has continued to evolve with the company.

Ladybird Books were popular and widely affordable, and the company became hugely successful. In the early 1970s the company was bought by Pearson and production moved to a purpose-built factory on Beeches Road. By 1998 the company had merged with Penguin and the publishing house moved to London. The Beeches Road factory still exists, now known as Ladybird House, home to the Anstey Wallpaper Company.

Still produced today, Ladybird Books are as popular as ever. In 2015 Loughborough celebrated the 100th anniversary of the creation of the Ladybird imprint, with a festival of children's illustrated literature – Loogabarooga. This has become an annual festival in mid-October when a huge variety of events take place across Loughborough.

DID YOU KNOW?
In 1965 Ladybird Books published the *Ladybird Book of London*. It's understandable that they would want to create a book for children about the UK's capital city. Interestingly, in 1988 Ladybird published their only other book that describes a specific location and its history – Loughborough. What prompted this informative little volume was the 100th anniversary of the incorporation of the borough of Loughborough, the town that had seen the birth of Ladybird Books and which was still publishing them there at the time of the book's publication.

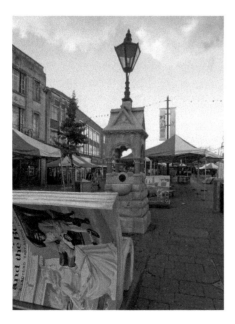

Rest awhile in Market Place.

Selection of books about Loughborough.

Hathern Station Brick and Terra Cotta Company

As the Hathern Station Brick and Terra Cotta Company was located 3 miles north of Loughborough, it is perhaps not a Loughborough secret. The company was renamed Hathernware in 1938, and there is a prevalence of Hathernware throughout Loughborough, the significance of which is probably less widely known.

When he founded the company around 1875, George Hodson was the sanitary inspector to the local Board of Health and was involved in the damming of the Blackbrook reservoir to provide Loughborough with a clean, regular water supply. Initially, the company made terracotta drainage equipment and decorative terracotta for building embellishment. There are some fine examples of Hathern's terracotta in Birmingham's Victorian pubs, particularly those designed by the architects James and Lister Lea, like The Anchor Inn, The White Swan and The Market Tavern. There are also stunning examples in Loughborough, such as the public library.

At the turn of the nineteenth century the company began to experiment with other building materials, and this evolved into the production of faience ware, a fine tin-glazed pottery on pale buff earthenware. The company name change to Hathernware reflected the production of this new material, of which there are some fantastic examples in Loughborough, particularly from the interwar period, when economic prosperity saw the town centre streets widened.

It is widely believed that Loughborough was used as a kind of showcase of Hathernware, something to 'wow' potential purchasers, hence the stunning local examples. Many such

Left: Terracotta embellishments on the public library.

Below: Hathernware tiles on the former *Echo Press* offices.

examples can still be seen today, including Beacon Bingo (formerly the Odeon cinema) the current Odeon, the former Echo Press offices, the Blacksmiths, and Baxter's Tea Rooms. Like the company's terracotta, there are also examples of the use of Hathernware in other towns in the UK. Interestingly, there is evidence of Hathernware atop the gate piers of the Masonic Hall in Loughborough, formerly an Independent Congregational Chapel building. Today, the company is part of Naylor's and is regularly involved in restoration and repair work. An overseas example of this is the Wrigley Building in Chicago, which has been expertly repaired using terracotta from Hathernware.

Fisons

The international company Fisons, of which there were several divisions, including pharmaceuticals, agrochemicals, horticulture and scientific equipment, had a strong presence in the town and had a number of offices at various times. Remember Gro-bags? These were produced by Fisons Horticultural Division. Remember those floral perfumes in exquisitely shaped bottles? These perfumes were made by Zenobia, a company taken over by Fisons when it bought a share of Genatosan. Remember Sanatogen, the tonic drink? That was also part of Genatosan, as was the convalescent and build-you-up drink Bengers, and the aspirin called Genasprin. People living with asthma might also remember Fisons for their asthma treatment named Intal.

Fisons also took over the Leicester company Charnwood Pharmaceuticals (formerly E. H. Butler & Son) and has itself been the subject of several takeovers, latterly by Astra-Zeneca. The company eventually moved out of Loughborough in 2011, vacating a large site that has now been transformed into a science park, Charnwood Campus, and is attracting interesting clients. These include pharmaceutical company 3M, who in 2018 vacated their premises on Morley Street, where they occupied the building originally associated with hosiers I. & R. Morley.

Terrace Mansion, once a pharmaceutical company, now a home valued at over £1 million.

5. People and Visitors

Henry VII's Visits (1457–1509)

There is an interesting piece of parchment visible in the window of an old shop on Church Gate. The short text refers to the building as the Great House, also known as the Lord's Place and Great Hall, and tells briefly of the building's ownership. The building was granted by Elizabeth I to Walter Coppinger and Thomas Butler, but was conveyed a year later to Sir George Hastings. A most interesting statement is that 'Henry VII slept here in 1486'. The Great House was constructed in 1477 as a guildhall, and in the Middle Ages was used as a hospital.

Richard III was defeated by Henry VII at the Battle of Bosworth in 1485, and it seems Henry VII visited Loughborough on his 'Royal Progress', possibly en route from Birmingham to Nottingham, having been crowned King of England. In June 1487, Henry VII again came to Loughborough with his army, this time passing through on his way to Nottingham from Leicester, and he made a further visit to the town in August 1495.

Henry VII slept here!

Since Henry VII's reign, many monarchs and other members of the royal family have visited the town. One of the most notable visitors was Diana, Princess of Wales, in 1990. In March 2018, Prince William visited the new Defence Rehabilitation Centre at nearby Stanford Hall. The Duke and Duchess of Sussex visited the university in September 2018 to participate in the Coach Core Award ceremony, where the achievements of young people in sports coaching were celebrated.

Robert Bakewell (1725–95)

Dishley Grange, the home of Robert Bakewell, is situated between Loughborough and Hathern, on the road towards Derby, and at one time served the abbey at Garendon. Having travelled around Europe and learned about a variety of farming methods, Bakewell was able to undertake pioneering work, both on land use and animal husbandry. He introduced innovative irrigation methods, like diverting rivers and building canals, and was the first agriculturalist to introduce selective breeding, which he called breeding 'in and in'.

Using his selective breeding techniques Bakewell had much success with his New Leicester sheep, and even more success with his Longhorn cattle, both of which provided more meat than the earlier breeds had done. Bakewell was also a pioneer in ram-letting: he would rent out his prize-winning rams to other farmers to enable them to improve their own flock.

John Skevington (1801–50)

John Skevington was born to a Primitive Methodist preacher and his wife, and himself began preaching at an early age, touring the country in the 1820s. He became treasurer of the Primitive Methodist church in Dead Lane, but left in 1836, around the time Chartism was beginning to develop. Partly because of his oratory skills and partly because of his

Welcome to Dishley, home of Robert Bakewell.

John Skevington, local Chartist leader.
(Leicestershire County Council)

adherence to democracy, Skevington was chosen to represent first Loughborough (1838) and then Derby (1839) in the General Convention of the Industrious Classes at the First Chartist Convention. He had previously supported the weavers of Barnsley and had organised many political unions in and around Loughborough. Skevington continued to support Chartism until his death in 1850.

Thomas Cook (1808–92)
Thomas Cook, born in Melbourne, Derbyshire, but residing for much of his life in Leicestershire, was a great supporter of the temperance movement. On 5 July 1841, he organised a day trip from Leicester to Loughborough for a temperance meeting in the town and a picnic on Mr Paget's park, now known as Southfields Park. Around 500 folks joined the outing and each paid 1s to travel on the Midland Main Line from Leicester to Loughborough. It is widely believed that this was the start of Thomas Cook's package holidays. This excursion is commemorated by a white plaque at both the Midland Main Line station and the entrance to Southfields Park.

Arthur Paget (1832–95)
Arthur Paget, son of a Leicester surgeon, was born in 1832. He came to Loughborough having served a three-year pupillage with Messrs Sharp, Stewart & Co. of Manchester. Their business was centred around iron founding, boiler making, machine making, millwrighting and toolmaking, a grounding that would help Paget with his later inventiveness.

Paget worked at the hosiery firm of Paget and White, based on Wood Gate in Loughborough for a period of around two years. Initially he was an engineer and later a manager, before becoming a managing partner in the firm. He eventually set up his own engineering company in 1866, manufacturing textile machinery.

Paget was a prolific inventor. His steam-powered knitting machine was exhibited at the Paris Expo in 1889, and his cricket scoreboard was in use at Lords and Trent Bridge

Commemoration of Thomas Cook's first package tour!

Radmoor House, former home of Arthur Paget.

cricket grounds for a number of years. Arthur and his wife Rose lived in Radmoor House, a substantial Victorian property in Loughborough that later became a nursing home and the birthplace of many a Loughborough baby. Today it is student accommodation.

Margaret Lockwood (1916–90)

The *Nottingham Journal* of January 1948 stated that actress Margaret Lockwood had been voted only a few days earlier as Britain's third biggest box-office draw. Having visited Derby in 1947 and been described as looking as though she had just stepped out of a film, Lockwood was visiting Nottingham in 1948, the same year that saw the creation of the National Health Service. She was touring the country as an ambassador of British films, and in Nottingham she visited both the Raleigh and the Boots factories, as well as making a personal appearance at the Empire Cinema in Mansfield during a screening of her film *The White Unicorn*.

After traveling to Burton, Lockwood then came to Loughborough. At the King's Head Hotel she was greeted by a large crowd of mostly schoolchildren and young working

women. The mayor (Councillor Miss Hilda Dormer) and the mayoress (Mrs A. Ives) and others, including the manager of the Odeon Cinema, were also present. After lunch she visited the General Hospital on Baxter Gate and then went on to the Brush. Later, during the evening ball, in the town hall she became unwell, but Lockwood recovered enough to make a visit to another Loughborough engineering firm – probably Cotton's – the next day, before travelling to Peterborough.

Patrick McGoohan (1928–2009)
Although born in New York, Patrick McGoohan moved with his family, first to Ireland, next to Sheffield, and then to Loughborough around the time of the Second World War, when he attended Ratcliffe College. He later returned to Sheffield as stage manager of the Sheffield Repertory Theatre, where his acting career began when he played a part in the place of an ill actor. During the 1950s McGoohan was a member of the Midland Theatre Company, which for a time played every three weeks at the theatre associated with Stanford Hall. After appearing in several film and television roles, McGoohan played the West End before embarking on his most famous works – *Danger Man* and *The Prisoner.*

Mark Williams (b. 1959)
The Grand Union Canal, once a busy transport network for carrying coal and other trade goods, and now mostly alive to the sound of holidaymakers on boating trips, isn't just a place to take a peaceful walk and observe nature. At one time there were several pubs along its length in Loughborough, but today only The Boat remains, just off the Meadow Lane Bridge.

It was outside The Boat Inn that the Mikron Theatre Company used to perform their social history plays – one stop in a long itinerary that took them to many venues up and down the country over the course of the summer months. As a travelling theatre company, with a base in Marsden, near Huddersfield, Mikron (named after the founders of the company) travel between venues on their trusty narrowboat, *Tyseley.*

The Boat Inn, venue for the Mikron Theatre Company.

DID YOU KNOW?
An unmarried lady-in-waiting to the Duchess of Kent, mother of Queen Victoria, was suspected of having an affair with Sir John Ponsonby Conroy. This caused a scandal, but upon examination the royal doctors diagnosed not the pregnancy that had been rumoured, but advanced liver cancer. The lady in question was Lady Flora Elizabeth Rawdon-Hastings, daughter of Francis, Earl of Moira, whose sale of Loughborough shaped its history.

In one of their early 1980s plays there was a colourful character, dressed in black pinstripe trousers, black shirt with a blue spotty tie, and wearing a sailor's hat. It was a superb play, and the performers were excellent. No one can know what the future holds, but it's likely the audience were simply enjoying the show and not considering where a jobbing actor might go next. Had they known what they now know, would they have been star-struck, or maybe 'spell-struck' would be more appropriate, given that the actor in question was none other than Mark Williams, who plays Mr Weasley in the Harry Potter films.

Since those early days in Mikron, Williams has become an established actor and starred in many films and television shows, including *101 Dalmatians*, *Father Brown*, and a rather memorable television advert for Prudential Pensions, the marvellous catch line of which was 'We wanna be together!'

Television and Film
There have been many Loughborough people involved in television programmes over the years, including David Neilson, who has played Roy Cropper in *Coronation Street* since 1995; Deirdre Quemby, once a dance teacher and a stand-up comedian, who played Lulu Dingle in *Emmerdale* in 1997; Fred Bowers wowed the *Britain's Got Talent* judges with his breakdancing in 2009; and Bill Brookman astonished the same programme's audience in 2016.

Aside from local people, the Great Central Railway has also played a big part in several blockbuster films and one spectacular episode of *Top Gear*. The three presenters hauled a row of caravans attached to a modified car along the length of the double track from Leicester North to Loughborough. En route, one of the caravans, masquerading as a buffet car, caught fire, and at the end of the journey there was a crash.

The GCR has appeared on other television programmes, like a couple of episodes of *Casualty*, and in *Full Steam Ahead* and *Goodnight Mr Tom*. Films using the GCR as a location include *The Hours*, starring Nicole Kidman; *Shadowlands*, with Anthony Hopkins; and *Cemetery Junction*, which featured Ricky Gervais. In this last film Gervais played Mr Taylor, a factory worker, and some scenes were filmed in Taylor's bell foundry.

Recently the Mountsorrel Railway branch line reopened. In the past this line used to transport stone from the local quarries to Swithland Sidings for onward journey to destinations across the UK. It was this branch line that appeared in an episode of the television drama *Victoria*, when Victoria, played by Jenna Coleman, took a journey on a replica of George Stephenson's *Planet* with Albert, played by Tom Hughes, an actor who

Great Central Railway, Mountsorrel branch line.

had taken part in *Cemetery Junction*. In 2018 *Stan & Ollie* was filmed at Loughborough GCR station and at scenic points along the track, and Laurel and Hardy also appear on the Hospital Way mural.

Sportspersons

Since one of Loughborough University's specialisms is sports-related courses, it comes as no surprise to learn that there are many sportspersons who have links to the town. These include Lord Sebastian Coe, a Loughborough University student in the late 1970s and a research assistant in the early 1980s who in 1980 beat the world record for the 1,000 metres run. Once a member of Parliament, Coe was made a life peer in 2010, and in 2012 as well as being made pro-chancellor of the university, he also headed the successful 2012 Olympic bid. Lord Coe continues to be associated with Loughborough and in 2017 he was officially installed as chancellor of Loughborough University.

Other notable sportspersons with a connection to Loughborough include long-distance runner Paula Radcliffe, cricketer Monty Panesar, the javelin thrower Steve Backley, David Moorcroft, the middle- and long-distance runner, and Paralympian Tanni Grey-Thompson.

The Scottish international footballer turned broadcaster Bob Wilson studied at Loughborough College. He played for Arsenal football club between 1963 and 1974.

On Saturday 12 December 1896, Woolwich Arsenal, which was the name of the club before it became simply the Arsenal, played against Loughborough Athletic and Football Club. The Loughborough team were in the second division, but scored their best ever result, winning the game 8-0. Sadly, the Loughborough team only existed for fourteen years, from 1886 until it folded in 1900.

Of course, Loughborough University isn't solely devoted to sport, so has other notable alumni and former staff, including artist Bridget Riley, antiques expert Philip Serrell and information systems scholar Chrisanthi Avgerou.

DID YOU KNOW?
Edmund Denison Beckett, First Baron Grimthorpe, QC, a bell ringer from the age of seventeen, became so involved in the work of Taylor's Bellfounders that Edmund Denison Taylor, born in 1864, was named after him. Taylor had a striking art deco garage built at the bottom of his garden at No. 6 Burton Walks, with its main access on Castledine Street, near 'The Shanty'. It is now Grade II listed.

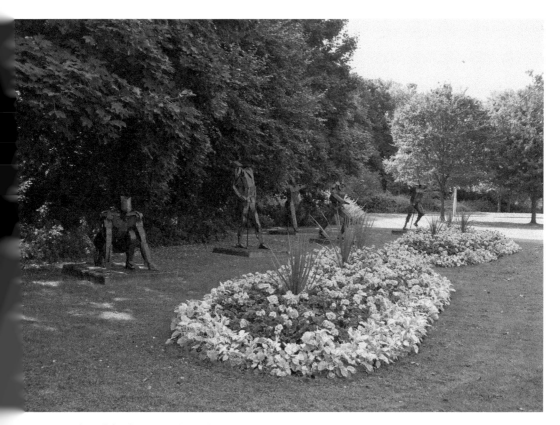

An 'In Bloom' display near *The Athletes.*

6. Secret and Not-so-secret Societies

United Ancient Order of Druids

The United Ancient Order of Druids was formed in 1833, when it broke away from the Ancient Order of Druids. The latter had been formed in 1781, but rejected the proposal in 1833 to become a registered friendly society and remained a fraternal society. By contrast, the United Ancient Order of Druids group formed as a friendly society. The Loughborough Hand and Heart Lodge No. 116 celebrated its formation in 1836 with a dinner at the Windmill pub. The landlord, Christopher Cleever, ensured the pub was beautifully decorated with evergreens and flowers intertwined around oak arches. More than sixty members and guests – including members of the new lodge, members from the Nottingham, the Hermitage and Ingleberry Lodges – attended the celebration, at which songs were sung and the guests left having passed a pleasant social evening.

When a lodge of the United Ancient Order of Druids was opened in Rearsby in 1841, Druids from Loughborough, Leicester and Sileby attended the event. Being a friendly society, the United Ancient Order admitted women to its lodges, and thus, in 1854, there was a tea meeting of female Druids held in a building on Moira Street. The landlady of the Blackboy pub, later to become the Blacksmiths, Mrs Birkin, provided the refreshments, and after the tea members and friends made their way to the Blackboy, where they danced until around 11 p.m.

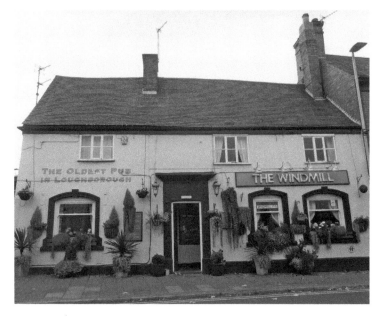

Windmill Inn hosted Druid meetings.

Noteworthy meetings of the United Ancient Order of Druids were held in local pubs, but curiously there is no mention of them being held in Loughborough's aptly named pub, the Druids Arms. During the period 1880–1902 this pub was one of the venues for local inquests and later a focus for sports club events, like the Loughborough Soar Angling Club's annual prize distribution. Today the Druid's Arms is no longer a pub, but is now a martial arts centre.

Oddfellows

Various branches of Oddfellows have held meetings and anniversary dinners in several different pubs in Loughborough over a period of 100 years. In 1836 the Independent Order of Oddfellows held their anniversary dinner at William Henshaw's Red Lion Inn, which had 102 attendees. In 1856 the United Brethren Lodge No. 18, Nottingham Ancient Imperial United Order of Oddfellows held their anniversary dinner at Mrs Brooks' Wheatsheaf Inn. This event attracted 100 attendees, but by the occasion of their anniversary dinner in 1862, when Mr Charles Clarke was the licensee, eighty diners attended, and the society had 195 members. After their dinner, the guests listened to a sermon delivered by Revd J. Mason at the Independent Congregational Chapel, Orchard Street, which is now home to local Freemasons.

Unity House, headquarters of the Loughborough Labour Party, was built in 1889 and it was here in the upstairs hall that the Loughborough Oddfellows Friendly Society once met. The building originally housed the Medical Aid Centre, which was a necessary service before the introduction of National Insurance payments in 1912 and greatly supported by local friendly societies.

In 1908 the half-yearly meeting of the Nottingham and Eastern Counties Conference of the Oddfellows Friendly Society (Manchester Unity) was held in Oddfellows Hall, and attendees were later served tea at the Temperance Hall in Devonshire Square, which is now a betting shop. The Oddfellows Hall was situated on Sparrow Hill, and had been constructed

The former
Oddfellows Hall.

as a theatre in 1823. The Oddfellows took over the hall in 1856 and today their badge is still visible on the front of the building, which is now an international supermarket.

At their centenary dinner at the Loughborough Hotel in 1934, the chairman of the Good Samaritan Lodge of the Manchester Unity of Oddfellows reminded the group that their lodge was not the oldest in the district, as the Sovereign Lodge had been established two years earlier in 1832. He also noted that it was interesting that societies were started in the premises of licensed victuallers and were now celebrating substantial anniversaries also in such premises.

Today, the closest branch of Oddfellows to Loughborough is the Pride of Leicestershire District Branch, based on Upperton Road in Leicester.

Ancient Order of Foresters

The Ancient Order of Foresters, now known as the Foresters Friendly Society, was created in Rochdale in 1834. Like most friendly societies, their aim was to be able to provide financial assistance to people when times were hard. The society gained legal status after the passing of the Friendly Societies Act in 1850, which repealed the previous Acts (1829, 1834, 1840 and 1846), and was itself repealed by numerous subsequent Acts. Like the Oddfellows, at one time the Foresters held their meetings in Unity House. In 2018, this national society operates a thriving savings, insurance and investment business.

Chartists

Active from around 1834 to 1848, the Chartist movement was formed as a reaction to the Great Reform Act of 1832, which saw middle-class property owners given the vote, and to the New Poor Law of 1834. Supporters of Chartism created a People's Charter, after

Unity House, a meeting place for various societies.

which the movement is named. The aims were to procure a vote for all men over the age of twenty-one, ensure ballots were secret, abolish the property qualification to become an MP, ensure payment for MPs, achieve electoral districts of equal size, and have annual parliamentary elections. Three separate petitions were delivered to Parliament in 1839, 1842 and 1848, but all were rejected.

At the time of the Great Reform Act, many Loughborough workers were employed in the hosiery trade. Poorly paid, they and other workers relied upon good harvests to keep themselves and their families fed. Chartism was adopted by people of the town after a run of bad harvests led to economic depression and hunger within the workforce. The leader of the local Chartists was John Skevington, the son of a Primitive Methodist preacher, and under his watch there was much activity in Loughborough.

Riots took place in towns like Manchester and Stockport, and in 1842 workers in Lancashire, Yorkshire and the Midlands tinkered with factory boilers to bring machinery to a halt. The movement all but died out after the rejection of the third petition in 1848.

Luddites

On the night of 28 June 1816, a group of men met in first one, then another, and possibly a third pub in Loughborough. After partaking of the local beer, they made their way down what was then called Maltmill Lane, now Market Street, towards the lace-making factory of Heathcoat and Boden. They allegedly smashed windows en route, before reaching the factory and shooting the night watchman, injuring him in the head.

If the men expected to find Heathcoat at the factory that night, they were unlucky because he was in Tiverton, Devon. If the men had expected to find Boden at the factory that night, again they were unlucky, but his whereabouts has always been a mystery. Could he have been in hiding, scared for his business and his life at the hands of the Luddites?

Heathcoat's house (left) and Boden's house (right).

Boden lived on Leicester Road in a house adjoining that of Heathcoat. In 2006, during renovation work a small group of local people had a chance to look around Heathcoat's house and were extremely excited by what they found within. Under the floorboards in one of the rooms was a trap door that led into a low-ceilinged room, just big enough for one person. There was also a curved tunnel leading out from the cellar, again with an entrance that was just big enough for one person to squeeze through. The garden was too overgrown to investigate claims of a tunnel entrance in what used to be the coach house. There was also alleged to be a tunnel from Boden's house leading to Heathcoat's. Is it possible that on the night in question Boden had access to these tunnels and had taken advantage of them?

There are rumours of other tunnels in Loughborough, too, perhaps leading from the Windmill pub on Sparrow Hill to the parish church, and in the vicinity of the former Manor House also on Sparrow Hill (now an Italian restaurant) and the guildhall on Church Gate (now a furnishers).

Freemasons

In January 2018, during a project to improve the heating, an amazing discovery was made at the Masonic Hall on Orchard Street. The building had started life in 1828 as an Independent Congregational Chapel, and was bought by the Howe and Charnwood Lodge No. 1007 around 1956, becoming operational by 1964. A collection of archival documents,

Loughborough Masonic Hall.

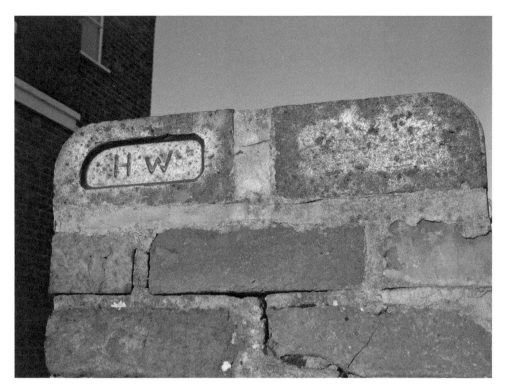

Hathernware bricks outside the Masonic Hall.

Masonic artefacts and memorabilia were found in a number of chests hidden behind a panel. This collection may have been earmarked for display when the idea of a local Masonic museum was on the cards, but this museum has now opened at the headquarters of the Leicestershire and Rutland Freemasons in Leicester.

The Freemasons movement began in the UK in London in 1717, when four independent lodges joined forces to become a Grand Lodge. Locally, the Howe and Charnwood Lodge No. 1007 was consecrated in 1864. It replaced the defunct Rancliffe Lodge No. 608, which had been consecrated in 1835 but had decreased in popularity as early as 1839. The last meeting was held in 1848 and the lodge was erased from the roll of the United Grand Lodge in 1853.

The Howe and Charnwood Lodge No. 1007 initially met in the Bulls Head on High Street, moving to the Town Hall in 1901. It was so successful that a new lodge, Beacon Lodge No. 5028, was founded in 1928, and was followed by the Thomas Burton Lodge No. 7007 in 1950. In 2018 the Beacon Lodge held their 700th meeting. The lodges continue to be successful today.

Royal Antediluvian Order of Buffaloes

This long-established society (some suggest that William Shakespeare and Elizabeth I were members of it) allegedly began as a drinking society. It was formally created in 1822, but later took a lead from the Society of Freemasons to become more of a

friendly society. On his safe return from the Boer War, Mr Henry George Lovett MC, DCM, a prominent local member of the Buffaloes, was landlord of The Clarence Inn on Clarence Street (later to become the Jack 'O Lantern and now rental apartments) in 1903. The Old Boot pub was rebuilt in 1906 to 1911 to a design by local firm Albert E. King, replacing a building that had been opened pre-1774, and Lovett became landlord. At the time of his death in 1925, Harry Lovett, as he was known, was still the landlord of the Old Boot. It is reported that his military funeral was attended by thirty members of the Buffaloes.

There is no connection between the Royal Antediluvian Order of Buffaloes and William Frederick 'Buffalo Bill' Cody, who came to Loughborough on Wednesday 21 October 1903. The Wild West Show, comprising hundreds of performers, arrived via the Midland Main Line Railway early in the morning. They travelled down Nottingham Road, Clarence Street and Toothill Road and onto Derby Road towards the racecourse just beyond Swingbridge Road. Several horses had to be dragged out of the waterlogged field, but a great many people visited the show and the weather remained fine. This was one of the last stops in the UK before Cody and his show returned to the US.

DID YOU KNOW?
Over the years Loughborough has been home to several theatres. The Theatre Royal on Market Street was designed by Albert E. King and opened in 1905, but was closed for good in 1953. Loughborough Amateur Operatic Society presented the final show, *Merrie England*, in February. LAOS had been created in 1895, and played one of their first seasons (in 1896) at the New Theatre on Ashby Road with *The Sorcerer*, but when that closed in 1901 the company played a variety of venues. Today LAOS perform at Loughborough Town Hall.

7. The University and Its Secrets

Sitting as it does in the top ten of several national league tables – *The Times* and *Sunday Times*, *The Guardian* and the *Complete University Guide* – as well as ranking No. 1 in the *Times Higher Education Student Experience Survey*, the university is well known and important to Loughborough, so is not a secret itself. It does, however, hold some secrets in its buildings and grounds, as well as its notable alumni, covered in an earlier chapter. We have heard too about the elderly cedar tree, and talked of some of the university's famous sportspersons, but there is more to discover.

The university campus is situated on one of the highest points of Loughborough, and it is thought that at its pinnacle is an Iron Age hill fort. Archaeologists from Loughborough Archaeological Society and a group from Channel Four's *Time Team* undertook a dig in the suspected vicinity of the fort in 2003, and established that this was likely to be an area of ancient settlement.

Not far from that grassy area is a poignant reminder of past staff and students of the university, tucked away in a tranquil, more secluded part of the campus, adjacent to the

University's Garden of Remembrance, Summerhouse and wall of memorial plaques (right).

old gardener's cottage. This Garden of Remembrance was opened in 2001 and there are plaques here commemorating those with an association with the university, which are mounted on a wall that once formed part of the Burleigh estate. The little summerhouse with its neatly tiled roof, recently renovated and sparklingly white, has views of the decorated seventeenth-century red-brick walls and is a welcome place to reflect. To the front of the Garden of Remembrance is the walled garden, a lawn bisected by a little path with a semicircular covered seating area at its summit.

The nearby gardener's cottage is a Grade II listed property, which was once one of many buildings associated with Burleigh Hall. It is believed that Burleigh Hall was besieged by Parliamentarians in 1644 during the Battle of Cotes, when King Charles's Cavaliers were chased back to Burleigh Hall – at the time in the possession of the Hastings family, one-time lords of the manor of Loughborough. Sometime between 1650 and 1700 the hall became the family seat of Sir William Jesson. Both Sir William and his wife died in 1711.

Since that time there have been various inhabitants at Burleigh Hall. These include the Tate family, starting with Henry and ending with Miss Julia Tate in the 1860s. The Kemeys-Tynte family held Burleigh Hall from around 1864 until the death of Colonel Charles John Kemeys-Tynte in 1882. Evidence of the family is discoverable along Ashby Road, Loughborough, where there is a house named in their honour. Following the colonel's death, Burleigh Hall passed to Revd William Henry Cooper, a member of the clergy who had previously resided at Weddington Hall (sometimes called 'Weddington Castle'), near Nuneaton.

After living at Burleigh Hall for twenty years, Revd Cooper moved away to Stamford in 1902, where he died the following year, and Burleigh Hall became the home of the Honourable Alan Joseph Pennington, son of the 3rd Baron Muncaster. Pennington had fought with the Royal Navy at the Siege of Sebastapol and reached the rank of lieutenant in the Rifle Brigade. He died in 1913 at his other home in Middlesex.

Tynte on Ashby Road, remembering the Kemeys-Tynte family.

During the time of the next inhabitant of Burleigh Hall, Howard Coltman, a Messenger glasshouse was constructed. Coltman and his family remained at the hall until 1958 when it was purchased by Loughborough College.

In 2018, near one of the lodges to Burleigh Hall on the Ashby Road, a new Elite Athlete Centre has been built. This state-of-the-art facility has forty-four bedrooms, twenty of which are altitude rooms, which have adjustable climatic conditions that can simulate an atmosphere comparable to Everest base camp, in order to better prepare athletes for challenges.

DID YOU KNOW?
Have you ever noticed the weathervane atop the Hazlerigg building? It was placed there at the time the building was erected and shows a group of students waving farewell to Dr Herbert Schofield, principal of the Technical Institute, who was about to embark on a long voyage. Some students were clearly distressed; however, they needn't have worried because Schofield returned safely from his journey and held the post of principal for thirty-five years – between 1915 and 1950. The weathervane was replaced in the 1960s as it had not weathered well, and was restored in 1983.

Across the campus evidence of the university's early beginnings as a college can be seen, along with its development and progress right up to the university it is today. Rutland Hall was opened in 1932, followed by Hazlerigg Hall in 1938. Between these times, in 1934 an arched gateway into Rutland Hall and the athletic ground was donated by William Bastard, the chair of the college governors (not by Frank Bastert, the partner of Herbert Morris, as is commonly thought). There followed many new buildings: the Victory Sports Hall in 1946; numerous buildings throughout the 1950s–70s, including the impressive Towers hall of residence; the Pilkington Library at the start of the 1980s; and various sporting venues from the end of the twentieth and into the beginning of the twenty-first century, leading today to the Elite Athlete Centre mentioned above.

With the increase in the number of students on campus over the years, the university is a bustling and busy place to be. In addition to the Garden of Remembrance and the walled garden, both designed to be quiet and peaceful, is the Butler Court Nature Conservation Area in the East Park, alongside Butler Walk. This tranquil part of campus has been left as natural as possible to encourage wildlife to inhabit the area, and provides students and staff with a place to reflect.

Close to the Bastard Gates and the Student Union building (opened in 1977) is an 1850 James Watt steam engine, proudly sitting on a plinth of red brick. The London Metropolitan Water Board donated the engine to Loughborough College in 1934, around the time they were replacing the board's steam plant with diesel and electric-powered pumps at their treatment works.

The university has produced a range of self-guided walk leaflets that highlight parts of the campus, particularly its buildings and heritage. There are seven walks in all, covering

Bastard Gates, former entrance to the university.

The Olympic torch passing through Loughborough in 2012.

most of the areas of the campus, and including an extended twenty-five-minute walk in Burleigh Wood and a walk following the route of the 2012 Olympic torch.

As well as having buildings on its own campus, over the years the university and its predecessors have made use of buildings in the town, some purpose-built, others not. Properties acquired for residential use included a pair of double-fronted Victorian houses on Forest Road in 1918; the Holt, a late Victorian red-brick property, which opened in 1919; the Elms, formerly the home of the Warner family, which opened in 1920; the Grove, at one time home to the banking family of Middletons, which opened in 1925; and Quorn Hall, another former home of the Warner family, which opened around 1938.

Properties that were used as teaching rooms included, among others, the former public library and council offices on the corner of Green Close Lane and Ashby Road, later joined by further purpose-built structures along Green Close Lane; the East Block workshops, which opened in 1918; and the Generating Station and garage workshops (now known as The Generator), which opened in 1937.

There are stained-glass windows in the Hazlerigg and Rutland buildings. These represent the coats of arms of the home countries of Loughborough College students at the time the halls of residence were built (1932–38). A further stained-glass window, which shows the principal Herbert Schofield amid areas of learning appropriate to the college, was installed in one of the college buildings on Green Close Lane. When this building was demolished in 1982, the window was saved and put in pride of place in the Edward Herbert Building, although these are now obscured.

DID YOU KNOW?
Hidden around the university campus are a myriad of sculptures. Many of these are included on a campus art trail and range from *The Watchers* outside the Herbert Manzoni Building to *The Athletes* on Ashby Road, the *Standing Figure* to the nearby *Standing Stone*, and from *The Wall* to *The Pulse* via *The Spirit of Technology*. As the campus is now around 438 acres in size, there's plenty of room to showcase the work of staff, students and other artists.

Former university houses, Forest Road, with a Victorian postbox.

Former university building, Green Close Lane.

Loughborough in London

In 2013, Loughborough University acquired the former press and broadcast centres of the 2012 Olympic and Paralympic Games, which were based on the Queen Elizabeth Olympic Park, London. The university's London campus complements the offering of that in Loughborough and is focussed on master's and PhD programmes.

This connection between Loughborough and London is not, however, the first to be made. Henry Hastings was born in the Manor House in Loughborough and, having supported Charles I in the Civil War, was elevated to the title of 1st Baron Loughborough of Loughborough in 1643. In 1648, having rebelled and been involved in the Siege of Colchester, he avoided execution by fleeing to Holland, only returning to England upon the restoration of the monarchy. Although appointed as Lord Lieutenant of Leicestershire in 1661, Hastings did not return to Loughborough, but lived in the Manor House at Lambeth Wick London until his death in 1667. This property, which Hastings renamed 'Loughborough House', was situated on an estate once owned by the archbishops of Canterbury.

Around 3 miles from Lambeth Wick is Loughborough Junction railway station, once the intersection of three railway lines, and so named because of its proximity to the former home of Hastings. Adjacent to this is another 'Loughborough House', which has recently (2014) been redeveloped, as a result of which an extra storey has been added and the inscribed name stone lost.

Just as there was more than one Loughborough House, Hastings was not the only Baron Loughborough. The Scottish politician and lawyer Alexander Wedderburn sat in the House of Commons from 1761 to 1780. In 1780 he was raised to the peerage and created Baron Loughborough, although this designation was changed in 1795 from Loughborough in Leicestershire to Loughborough in Surrey, thus rendering the Leicestershire title extinct. From 1793 to 1801, Wedderburn was the Lord Chancellor of Great Britain and was created 1st Earl of Rosslyn in April 1801.

In 1786 Wedderburn bought land facing the Stray, Harrogate, and built Wedderburn House, possibly incorporating part of an earlier house on the site. As Wedderburn died in 1805 without issue, Baron Loughborough of Loughborough (Surrey) has been passed down through his nephew. Peter St Clair-Erskine, 7th Earl of Rosslyn, uses the name Peter Loughborough, the latter coming from his subsidiary title of Lord Loughborough. Loughborough's son, Jamie William St Clair-Erskine, has the title of Lord Loughborough.

Today Wedderburn House is honoured with a Harrogate brown heritage plaque – one of over eighty in the town. The Charnwood Heritage Plaque scheme was only begun in 2018. Loughborough falls in the Charnwood region and there are plaques to be found on the gate piers of the Army Reserve Centre building on Leicester Road and on the front of the Town Hall in Market Place. The latter commemorates the soldiers of the Royal Leicestershire Regiment and the Leicestershire Yeomanry, who mobilised for the First World War in Loughborough Market Place in August 1914. During that war, Loughborough

Former Manor House, Sparrow Hill.

Charnwood Heritage Plaque,
Leicester Road.

College became an instructional factory, where over 2,000 men and women were trained to make shell cases and machine parts for the Ministry of Munitions.

Olympics

In the run up to the 2012 Olympics, Loughborough University was the operational nerve centre, training base and pre-games preparation for Team GB. With, among other things, its Olympic-sized swimming pool and its National Cricket Performance Centre, first-rate training for the athletes was a given. Not only is evidence of Loughborough's success in the Olympics obvious through the medal count of its competitors, but the Olympics dominate the town.

At its New Street entrance, Queen's Park is the location for a set of Olympic rings, flanked by a variety of plants and activities for children. In 2012, the nearby ponds were the setting for a group of sculptures created by students of the university who won a competition to have their artwork displayed for a year. The chosen work was a series of legs positioned in the pond and pointing skyward, to represent the synchronised swimmers. This competition also took place in the two subsequent years. In 2013, bell-related sculptures were created and in 2014 war-related sculptures were installed, which can still be seen today. During the changeover from *Synchronised Swimmers* to bells, the swimmers' legs could be seen in the incongruous situation of the groundskeeper's yard!

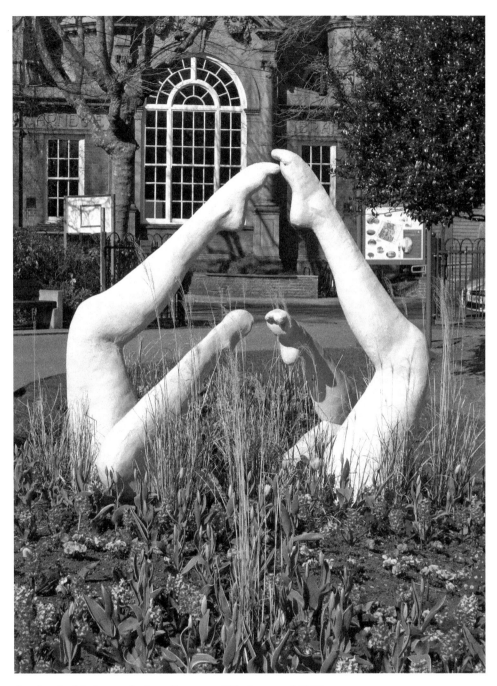

Synchronised Swimmers by Lucy Buzzacott, Mike Jones and Abi Ross.

8. Glorious Gallimaufry

The Earl of Moira's Sale

Francis Rawdon Hastings (1754–1826) was the Earl of Moira from 1793 to 1816. He took the surname Hastings as decreed by his uncle, the 10th Earl of Huntingdon, thus becoming the Marquess of Hastings at the end of 1816. It was in 1809 that the Earl of Moira had his great sale of lands, dwellings and properties in Loughborough.

The Earl of Moira owned land across the country, but at a time of economic expansion realised the potential value in exploring coal mining on his land in north-west Leicestershire. Loughborough was becoming increasingly prosperous, and he considered that by selling much of his land and buildings here he could raise the money needed, as burgeoning prosperity meant people would be able to afford to buy them.

However, personal circumstances dictated that the only way to achieve such sales was through a Private Members Bill to Parliament. The Earl of Moira's Act of 2 July 1808 was successful, and his properties auctioned at the Bull's Head Inn on High Street in late 1809 and January 1810. Many of the properties were already leased out to the people who bought them, and the sales particulars are a great source of information about the town; for example, the people who were using the properties, their occupations and where the properties were situated.

Lot 51, a house and yard on Sparrow Hill, occupied at the time of the sale by the architect Christopher Staveley who had worked on the nearby Old Rectory around 1800, was bought by Staveley for £75. Lots 154–157 in Market Place were several shops – a glover's, a hatter's, a grocer's and a drapers. Lot 162, the Griffin pub, was situated on Bear Place, today known as Ashby Square. The street we now know as Market Street was known as Maltmill Lane in 1809, with a brook running across it as mentioned in Lot 150, and outbuildings and a yard backing onto it from Market Place as described in Lot 151. The scale of this sale was so successful that the Earl of Moira was able to develop the coalfields of north-west Leicestershire, and the village of Moira therein is named in his honour.

DID YOU KNOW?
The bell sculptures that were in Queen's Park from August 2013 to August 2014 can still be seen around the town. The bell clapper is at the New Street entrance to the park, and the four stacked bells are a feature on the Chapman Street housing area. On the bell foundry site itself, next to the Chapman Street housing, is the foundry's campanile, housing a ring of twelve bells.

Lot 152

THE ANGEL PUBLIC HOUSE, consisting of a Substantially
Built Brick and Slate Messuage, well situated in the
Market Place, with good Stables, Yard and Garden, in the
Occupation of Thomas Andrews.

A Messuage in the Yard, in the Occupation of Widow Peck, with
Malting Rooms, and Pigstyes; on Lease to Samuel Peck
for an unexpired Term of 23 Years from Lady Day 1810,
at the Yearly Reserved Rent of £12, and containing
0A. 0R. 29P. be the same more or less. S. Peck, £410.

Lot 153

A BRICK and THATCH HOUSE in the Angel Yard, with
Stable and Garden, in the Occupation of John Sumners,
and on Lease to him for an unexpired Term of 23 Years
from Lady Day 1810, at the Yearly Reserved Rent of £6,
and containing 0A. 0R. 9P. be the same more or less.

Lot 154

A MESSUAGE and GLOVER's SHOP in the Market Place,
with Stable in the Angel Yard, and good Garden in the
Occupation of Thomas Ackeley, and on Lease to him for
an unexpired Term of 23 Years from Lady Day 1810, at
the Yearly Reserved Rent of £6, and containing
0A. 0R. 11P. be the same more or less. Court £210.

*The Purchasers of Lots 152, 153, and 154 to have the Use of the Angel Yard,
in the same way that is now enjoyed, by the Occupiers of the
respective Lots.*

Lot 155

A CAPITAL and SUBSTANTIALLY BUILT MESSUAGE
in the Market Place, comprising several convenient and
well finished Rooms, with excellent Offices, Yards, and
good Garden, in the Occupation of Mr. Henry Eddowes.

A MESSUAGE and Hatter's Shop adjoining, with good Front
to the Market Place, in the Occupation of John Toone;
on Lease to Henry Eddowes for an unexpired Term of
23 Years from Lady Day 1810, at the Yearly Reserved
Rent of £14, and containing 0A. 1R. 6P. be the same
more or less. Toone, Belton, £600.

Extract from the Earl of Moira's sale catalogue.

Charnwood Forest

Leicestershire is known for its fox hunting, and particularly for the Quorn Hunt. Quorn in the Soar Valley gives its name to the local hunt, and is but a stone's throw away from the popular hunting area of Charnwood Forest. Charnwood Forest, unlike its more famous neighbour, Sherwood Forest, was not a royal forest, so the monarch did not have exclusive hunting rights. The forest was countryside used for hunting and was typical medieval hunting land, comprising expansive woods with large clearings and outcrops of rock, which had been dispersed and displaced by earlier volcanoes and glaciers.

Part of the route of the Charnwood Forest Railway branch line, known as the Bluebell Line, which around 1883 linked Coalville in north-west Leicestershire to Loughborough, passed through the Charnwood Forest area. Run by the London and North Western Railway, it became part of the London Midland and Scottish Railway in the big merger of 1923. Passenger services came to an end in 1931, but the line continued to carry freight until 1963. In 2018 the site of the Loughborough railway station began being redeveloped for a supermarket, and the Station Hotel is now a funeral parlour.

The Charnwood Forest Canal, constructed around 1784, also ran through Charnwood Forest and carried goods – particularly coal, stone and slate – from north Leicestershire to the Grand Union Canal. The canal terminated at Nanpantan and goods were carried onwards via a horse-drawn wagonway. However, by 1808 the line had become uneconomic to run and went out of use. In 1846 the long process of selling the land was eventually successful. Visible remains of these former transport links can be seen along the public footpath through the Longcliffe Golf Club.

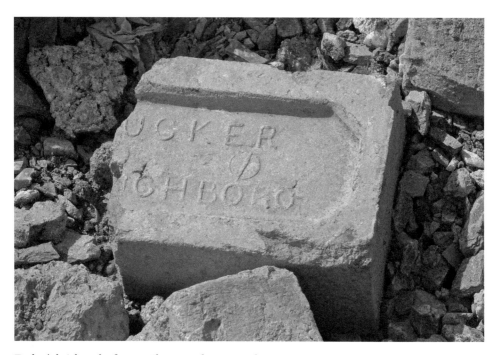

Tucker's brick at the former Charnwood Forest Railway site.

Former Charnwood Forest Railway goods shed.

The Old Rectory

The Old Rectory is found on Rectory Place, next to the church of All Saints with Holy Trinity. The former rectory is a medieval stone building that was revealed at the core of a substantial mansion during the demolition process in the early 1960s. This core was saved by the perspicacity and tenaciousness of the members of a group then called the Loughborough Archaeological Society, but known today as Loughborough Archaeological and Historical Society. During the dry summer of 2018, outlines of the former larger building were tantalisingly evident on the parched grass. The Old Rectory is now home to a small museum, which houses a changing exhibition downstairs and a display of local artefacts upstairs.

St Peter's Church, Storer Road

The church of All Saints with Holy Trinity was originally dedicated to St Peter and St Paul before becoming All Saints. It later became All Saints with Holy Trinity when the nearby Holy Trinity Church fell into disuse. While known as All Saints, a new church dedicated to St Peter was built on Storer Road. Designed in 1909 jointly by William Samuel Weatherley of London and local architect George Barrowcliff, the first ceremonial stone was laid in November of 1910 and the church was consecrated by the Bishop of Peterborough on 26 April 1912.

St Peter's Church, Storer Road.

The Lady Chapel was built onto the church in 1962, but by 2004 the church was officially unused. Having been purchased by Elim Pentecostal and Open Heaven churches in 2013, after several years of renovation work the church reopened with a celebratory event for the local community. During the redesign of the church interior, a time capsule buried in 1911 was found and formed a focal point at the community event. The documents found in the sealed glass jar included an order of service and a deanery magazine, as well as information that revealed that there were around 700 children involved in the local Sunday school at the time.

Almshouses

Like many towns and villages, Loughborough has a number of almshouses. A group on Mill Lane dating from around 1895 were created for the Warner's Almshouses Trust for former employees of the hosiery manufacturer. Twentieth-century almshouses include a pair on Middleton Place built in 1925 as part of the Edgar Corah Trust (builders) for former employees, and a group on York Road built in 1930, part of a bequest made by Samuel Bernard Frost, providing accommodation for folk over the age of sixty who had lived in Loughborough for twenty years or more.

DID YOU KNOW?
William Railton (1800–77), the architect responsible for the design of Nelson's column in London, was also the designer of many buildings in and around Loughborough, including Beaumanor Hall, Grace Dieu Manor, and some of the lodges on the Garendon estate. Railton was enticed to Leicestershire by the owners of Garendon Hall after their conversion to Catholicism, and it was for their estate at Garendon that he designed the striking Bavarian Gates, also known as the Red Arch.

The Secrets of Garendon

The Garendon estate was once the location of Garendon Abbey, which was founded in 1133 by Roger de Beaumont, 2nd Earl of Leicester. The church was demolished during the dissolution in 1536 and Henry VIII sold the dilapidated abbey and land to the 1st Earl of Rutland, who built Garendon House. The estate then passed through the hands of the dukes of Buckingham before being sold in 1684 to Sir Ambrose Phillipps, whose descendants still own it today. Since 1684 several follies and lodges have been built in the grounds, including an 80-foot-tall obelisk, the Temple of Venus, modelled on the Temple of Sybil in Tivoli and the triumphal arch, a replica of the Roman Arch of Titus. The house,

Plaque indicating Warner's almshouses, Mill Lane.

Bavarian Gates on the
Garendon estate.

later a hall, was extended and subsequently demolished, and it is widely reported that the
house was set on fire and used as a practice by the local fire brigade. The resulting rubble
was used as hardcore for the M1.

Brick Walls

Loughborough is full of red brick. Many of the houses are constructed of red brick, walls
are made of red brick, and bridges are red brick, as are culverts. The purpose of most of
these structures is usually obvious, apart from what might be regarded as a few oddly
placed walls. The Theatre Royal on Market Street, a venue for local performers and
national favourites, is now demolished, but evidence of its existence remains. Walking
along Packe Street, which runs behind Market Street, there's a low brick wall separating
two makeshift car parking areas – this is the only remaining architectural evidence of the
existence of the Theatre Royal.

It's difficult to imagine the Theatre Royal on the site now, but a trip down the
inner relief road will help the visualisation. Standing on Jubilee Way, looking across
from Cineworld to the buildings in the distance on the left of the award-winning
magistrates' court, there's a long, thin, windowless brick building. The entrance to this
building, currently an international supermarket, is on Sparrow Hill and at one time
this was Loughborough's first purpose-built theatre. Constructed in 1823, it was used
as a theatre for around thirty years, after which it became a dance hall and, as already

Rear of former
theatre,
Sparrow Hill.

mentioned, a meeting place for the Loughborough branch of the Oddfellows. It was
later an auction mart and various retail outlets. The depth of the building is typical of
that needed for such a theatre, and this is what the Theatre Royal might have looked
like from the side.

Hidden Haven in a Busy Town Centre

A King's Head Hotel has been situated on Loughborough's High Street since before 1828.
The current building was erected in 1929–30 after the previous building was demolished
in a programme of road widening. Created in Neo-Georgian style, evidence of the
building's age can be seen in the ceramic tiles decorating the driveway. What is not so
obvious from the roadside, however, is what the building hides within. Entering through
the main reception area and passing out the other side, one is transported to a plaza
reminiscent of an Italian village, where little tables and seats look out onto an ornate
stone fountain, with water cascading down daisy-shaped troughs. Any bedrooms with
windows facing into the square have a beautiful view.

Headstone Inscriptions

The churchyard of All Saints with Holy Trinity provides a rich history of Loughborough
and its townsfolk through the inscriptions visible on the headstones, many made using
the local slate from Swithland. In the 1960s the stones were rearranged, partly to form
paving around the church, with some stones being laid flat on the ground, others resting
against the edges of the churchyard and others standing tall in rows. From these stones
we learn that Thomas Towers, who died in 1773 at the age of eighty, was an apothecary;
James Mitchel, who was an ironmonger and a cutler, died in 1788 at the age of only
twenty-seven; and friends Thomas Bombroffe, William Peck and William Smith drowned
in the River Soar in 1767.

Mason's markings on Swithland slate headstone at the parish church.

The names of the masons who inscribed the words and images is also now revealed. Practice inscriptions that would previously have been buried in the ground are now visible on some of the headstones and range from short words to complete alphabets.

Ghostly Goings On

On the night of 10 November 2018, a group of local store employees were locked into a shop, formerly the Ram Inn, for an escape event, a night set for derring-do and excitement. But for one member of the group of thirteen an unexplained feeling of being far too hot and a feeling of sickness with a tightness around the throat was overwhelming.

Years ago inquests into deaths were often held in pubs, and a large number were held at the Ram Inn. During the period 1836–86 inquests were heard on at least five children who died of burns, several of whom had fallen into fires, and one of whom was caught in the explosion of a paraffin lamp. Between 1852 and 1881 there were at least seven inquests into deaths by drowning. One of these was a little lad of four who drowned near the Old Wharf. Many of the others were intoxicated adults who simply missed their footing and fell into the canal, with disastrous consequences. Could these inquests be the explanation behind the experience of that unsuspecting person who prior to the lock-in had little idea of the building's history?

Ghostly Signs

Whether or not ghosts were recently present at the lock-in in the former Ram Inn, there are certainly other ghostly sights to see around town, in the form of ghost signs. This is

usually a hand-painted sign on a building that has been preserved long after the business advertised has left the premises, thus providing interesting glimpses to the past.

The Offilers Brewery sign on the off-licence on William Street and the one on the former Stag and Pheasant pub on Nottingham Road have already been mentioned, but there are plenty of others. Also on Nottingham Road is one for the wool shop, and further down Nottingham Road towards the railway station is the former Towles hosiery factory, where the sign of the building's former purpose is painted on the side – the word 'Ltd.' is covered by the sign of the current occupants, SOFA. Directly opposite Towles and next to the newsagents on the corner of Queens Road is No. 85, whose faded ghost sign appears to have been overpainted a few times. What is still discernible is that at one time this shop offered the 'best selection of Paperhangings'!

Further down Nottingham Road, where it joins Ratcliffe Road, is another overpainted sign, advertising some kind of syrup for the treatment of indigestion. Some of the wording is difficult to read – does it say 'the world's remedy for indigestion'?

Heading back up Nottingham Road and turning left into Queens Road, then right into Freehold Street, there is a good example of a painted sign. It is not a ghost sign, however, as the company, Taylor's Bellfounders, is still thriving today.

Above left: Former Ram Inn, The Rushes.

Above right: Former wool shop, Nottingham Road.

Mileposts

A fantastic example of a milepost stands at the edge of town, on the Leicester Road near the cemetery – 108 miles to London, 10 miles to Leicester and 1 to Loughborough town centre. There is no indication of who made this beautiful milepost, but hidden on the back is information about who has been looking after it: 'Repaired by Blackcat ironwork: painted by Antony Stone 2013'.

On a brick post close to the milepost there is also an Ordnance Survey benchmark, identical to the one found on No. 9 Park Street. Also on Park Street, on the front of No. 7, is a Royal Insurance Company metal fire insurance plaque, with whom the property was at one time insured. The presence of this plaque meant that in the event of a fire the fire brigade would have tackled the blaze.

Back to mileposts, and a bit of a mystery. Outside the Organ Grinder pub stands a milepost that has recently been painted. It is still possible to see that London is 116 miles and Loughborough town centre 9 miles, but the distance to Derby is hidden beneath the pavement. It is believed that this milestone came from Shardlow and appeared there mysteriously one night when Harry Sheffield was the landlord of the pub – so sometime between 1912 and 1938.

A modern take on a milepost can be seen on the path leading between the Beacon Academy (formerly Shelthorpe School) and the cemetery. This looks like a brightly coloured totem pole and shows the direction and distance to Shepshed, Derby, Quorn and Leicester. It was created by children from the academy.

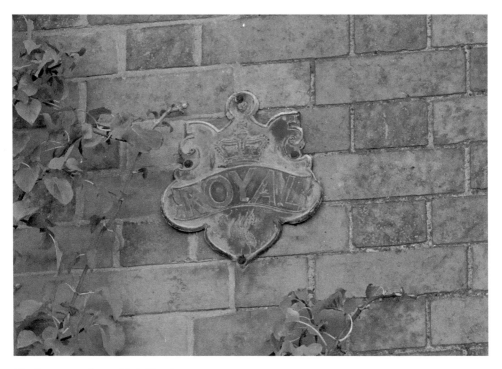

Fire insurance plaque, Park Street.

Milepost outside the former Pack Horse, Wood Gate.

Fairies

Fairies tend to be so secretive that there are many among us who don't even believe in their existence. But hidden away between the pedestrian and cycle path called Woodbrook Way and the Wood Brook itself, which runs parallel to Forest Road, are fairies in their tiny homes all along the path. This is quite a busy little path, but it's a haven for fairies and many kinds of wildlife. The area was created and maintained by Harry and Pat Cook from the nearby house, a house that is always stunningly beautiful with bright blooming flowers and themed displays. Helped by children from the adjacent school, they have created a bee-friendly array of plants, installed a couple of beehives, and made homes for moles and various other creatures and much more alongside the Wood Brook. Also along this path is another totem pole milepost.

Loughborough Library Local and Family History Centre

A short paragraph in an AA book *Secret Britain* highlighted the bell foundry, the Carillon, the Central train line and waxed lyrical about the photograph collection held by the Local Studies Library.

The public library is in a beautiful building, designed by local architects Barrowcliff and Allcock. It was constructed by local builders Moss and is faced with Tucker's bricks with terracotta detailing by the Hathern Station Brick and Terra Cotta Ltd., and has a heating system by Messengers. The Scottish industrialist and philanthropist Andrew Carnegie was a major benefactor, and the library was built on land given by Mr F. R. Griggs. So, this was a largely local affair! Today the building houses a hidden secret.

 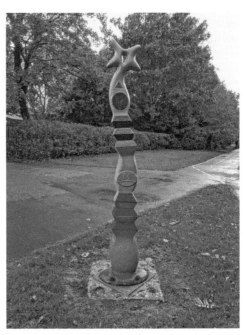

Above left: A fairy home, Woodbrook Way.

Above right: Totem pole milepost, Woodbrook Way.

If you are looking for information about Loughborough, photographs of the town and its people, or if you're after help with your Loughborough research or your family history research, or if you want to consult books, newspapers, photographs and a wide range of ephemera then the Local and Family History Centre inside the public library is the place to go. Previously known as the Local Studies Library, the centre has bags of resources and knowledgeable staff. They curate regular exhibitions featuring aspects of Loughborough; for example, Ladybird Books, the Loughborough Building Society, Taylor's, Zenobia and many more. You can find the collection and the staff in the older part of the library, towards the rear.

DID YOU KNOW?
An extensive network of culverts carry the Wood Brook underneath the town. Where they are visible, these culverts are concrete, but urban exploration groups have discovered beautiful brick tunnels beyond, and often give these amusing names, like 'Handbag Culvert'!

There are many more of Loughborough's secrets to discover, but if just one reader exclaims just once, while reading this book 'I didn't know that!' then author will have achieved what they set out to do.